MW00603942

HAUNTED ANNAPOLIS

GHOSTS OF THE CAPITAL CITY

MIKE CARTER AND JULIA DRAY

Haunted
America

Published by Haunted America
A Division of The History Press
Charleston, SC 29403
www.historypress.net

Copyright © 2012 by Mike Carter and Julia Dray
All rights reserved

Cover image by Rob van Schadewijk

First published 2012

ISBN 978.1.54020.761.6

Library of Congress CIP data applied for.

Notice: The information in this book is true and complete to the best of our knowledge. It is offered without guarantee on the part of the author or The History Press. The author and The History Press disclaim all liability in connection with the use of this book.

All rights reserved. No part of this book may be reproduced or transmitted in any form whatsoever without prior written permission from the publisher except in the case of brief quotations embodied in critical articles and reviews.

CONTENTS

CONTENTS

ACKNOWLEDGEMENTS

I wish to thank my amazing wife, Wendie, for being my muse and my sounding board over these many years. Thank you for keeping me on task from conception through tour script and finally to completed manuscript, for helping me focus my often scattered thoughts into cohesive ideas and, lastly, for dragging me on that first ghost tour in Charleston, South Carolina, and supporting me when I impulsively decided that I could create my own tour in Annapolis. Thank you, Sweetie!

—*Mike Carter*

For Richard and Kay Mobayed, who taught me that everything is a story; for my children, Robert and Mary, who were my first audience and constant cheerleaders; and for Rob, the patient and loving partner who reads every story I write. I am better, stronger, faster and practically bionic because I have you!

—*Julia Dray*

PREFACE

People ask me all of the time, "How did you get into ghosts, and why did you create the Annapolis Ghost Tour?" My answer is always the same: Annapolis didn't have a ghost tour, and once I knew the niche was there, I just had to fill it—because if ghost tours were thriving in other historic cities, I knew one would definitely work in Annapolis, a city with a rich and scandalous history.

It all began in the summer of 2001, when my wife and I were traveling along the southern Atlantic coast. When we visited Charleston, South Carolina, we went on a ghost tour for the first time in our lives. This was not some preplanned item on our travel itinerary, but rather a totally organic experience that completely changed my future. We were having breakfast at a table in a busy bagel shop in historic Charleston, and some previous diner had left a random stack of rack cards (brochures for tours, historic sites and the like). My wife began thumbing through them and, finding several for ghost tours, said, "This might be fun." My first response was far from enthusiastic. But in that way that husbands have of being persuaded by their wives, I agreed to go along, albeit with more than a fair amount of cynicism.

I was what we in the industry call a "drag along," a euphemism that needs no explanation, but after we'd wandered the lovely streets of historic Charleston (at one point in a hot, driving summer rain), listening to the guide spin ghost stories that wove history and real human beings into genuinely creepy tales, I was hooked! We went on to enjoy a haunted pub-

crawl in Savannah, and again, I was pleasantly surprised by how engaging an evening it was under the guidance of an experienced tour leader. At some point during our long drive back to Maryland, I turned to my wife and said, "We should do that in Annapolis." She agreed.

When we came home from vacation, I started doing research on the local legends and hauntings, and Ghosts of Annapolis Tours came into being shortly thereafter, offering walking tours and pub-crawls that focused on sharing the stories of spirits who just cannot rest. We've been scaring people ever since.

Senior tour leader Julia Dray began working for me in 2007, and it has turned out to be a great partnership that led to the writing of this book, which is the product of many years of research, interviews and personal investigation. She continues to lead groups through the darkened streets of historic Annapolis and is constantly adding new ghastly experiences and stories to our ever-evolving tours. The stories we've included are those that seemed most interesting to us, but these are not the only ghostly stories in Annapolis—talk to a native, and they might tell you about the ghost in their basement, attic or bedroom. It's an old city, and there are a lot of ghosts!

We hope you'll come to Annapolis someday, but be careful: we don't want to add YOUR story to our tour!

<div align="right">—Mike Carter</div>

INTRODUCTION

D o you believe in ghosts? Whether you do or don't, you probably still
enjoy a good ghost story around a campfire or have a memory of
chanting "Bloody Mary" three times in front of a dark mirror, not certain
if you wanted the famous ghost to appear or not. Ghost stories play into
our belief that there is something more "out there" than the things we
can see and touch, and they touch some chord within us—the best ghost
stories are the ones in which we see ourselves because we can identify with
the anger, desire for revenge, the deep sadness or other emotions that have
kept those spirits tied to the earth. You don't have to believe in ghosts to
appreciate the stories.

But if ghosts are real, what are they? Are they an echo of some
electromagnetic vibration trapped in a bizarre time warp? Are they the souls
of actual people, tormented by something that makes it impossible for them
to find rest after death? Perhaps they are merely the result of an overactive
imagination or an extra-spicy Mexican combination platter. The current
popularity of paranormal investigative television shows seems to argue that
most people believe ghosts are something more than imagination or bad
digestion, although opinions vary widely.

Until the early twentieth century, many people believed that ghosts and
spirits walked among them. In England and the United States in the mid-
to late nineteenth century, countless numbers of people experimented with
spiritualism, conducted séances and consulted mediums.[1] They spoke and

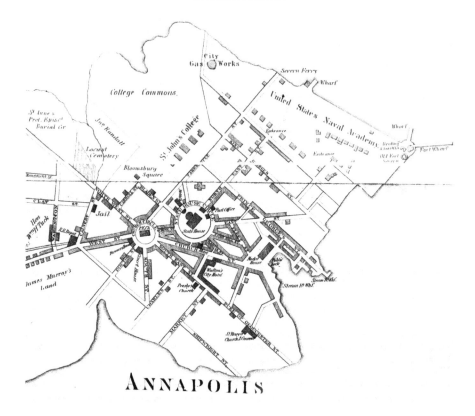

Map of the Historic District of Annapolis. *Courtesy of the Historic Annapolis Foundation.*

wrote freely of supernatural experiences and recorded such events in journals and diaries. It is from these accounts, from newspaper articles and from firsthand eyewitness sightings, that these stories are taken, supplemented by historical information about the people involved that cast some light on why the haunting exists.

We have not included "bump in the night" stories—odd happenings that may stem from paranormal activity but that cannot be connected to a particular individual specific event; if someone says, "There was a murder in this building and the guy walks up and down the stairs," you're only going to get nervous if you're sleeping there that night—it's not much of a story without the who, the when and especially the why.

Unlike many of America's "haunted" cities, current Annapolitans and visitors alike report encounters with the paranormal. This is not a collection of "Once upon a time…" or "way back when" stories; these ghosts are often active and still make their presences known. Many of the anecdotes

and accounts in this book have been passed down through families or local tradition for decades, while others are as recent as 2011.

Hopefully, you will have an opportunity to visit Annapolis, to walk its tree-shaded streets on brick sidewalks that lead past homes that still echo with sadness or crackle with rage, beneath soaring domes founded in blood and iron-barred graveyards that cannot contain the spirits of the restless dead.

But if you are not able to visit the Ancient City where it dreams beside the Severn River, this book is your passport to a place where the wheel of history has spun for more than 350 years and where the buildings and streets remain home to the unquiet spirits of days long past.

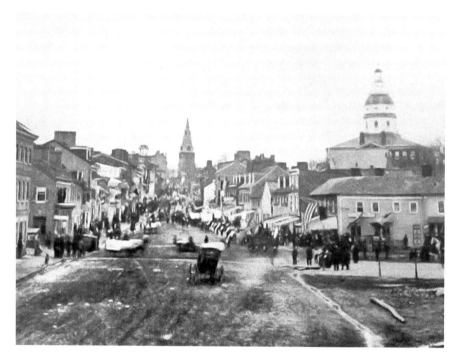

From docks crowded with the working boats of watermen, Main Street rises to meet the steeple-crowned circle about St. Anne's, the second-highest piece of ground in Annapolis. This scene, which dates to the late years of the nineteenth century, includes transient vendor stalls along the road and may portray a market day or special festival. *Courtesy of the Historic Annapolis Foundation.*

A BRIEF HISTORY OF ANNAPOLIS

The Historic District of Annapolis is a rough oblong against the waters of the Severn River. The land rises from ancient marsh up to a crest of land that is the backbone of the city; water flows down to College Creek on the north side and to Spa Creek on the south. In the northeastern section, the streets that radiate from State Circle carve large trapezoids out of the city land, with many of the houses boasting spacious gardens behind their brick faces and gated alleys; across Main Street to the south, the streets follow a loose grid, with smaller houses stacked tight together, the lines of them tumbling down the hills to the creek below.

Annapolis is a historical jumble, with stately five-part Georgian homes loftily ignoring the late-nineteenth or mid-twentieth century models across the street and extravagant Victorian woodwork jostled by steel and smoked glass, but there are long swathes of city blocks that boast one brick colonial building after another. The main streets are wide, cut by narrower roads that used to be alleys, and the blocks are sliced and diced by public and private alleys that remain widely in use today.

The settlement that became Annapolis was located originally on the north shore of the Severn River. Founded by Puritans who had been evicted from Virginia, the fledgling town was christened "Providence" but, within a few years, moved to the southern shore with its protected harbor, where it was known briefly as "The Town at Severn," among other names. Christened "Ann Arundel's Town" after the wife of Lord

Baltimore, the town was formally declared the capitol of the Maryland colony in 1694 and renamed "Annapolis" in honor of Princess Anne, who was later to ascend the throne of Great Britain and rule as the last monarch of the House of Stuart. In 1708, Queen Anne granted her colonial namesake a royal charter.

Home to four of the original signers of the Declaration of Independence, Annapolis was known by the middle of the eighteenth century for its intellectual liveliness, beautiful homes and cultural events. One of the oldest colleges in the United States, King William's School (later St. John's College), was founded there as a preparatory school in 1696 and received its charter in 1784, placing it behind only Harvard and William and Mary in order of founding. Spacious and elegant homes and churches rose along the streets, and today the city has more surviving colonial buildings than any other in the United States. Skilled craftsmen created furniture from native woods, artists set up studios for commissioned portraits and musicians played concerts for rapt crowds. Thoroughbred racing had its beginnings outside of Annapolis at Belair Mansion in Bowie, where Provincial Governor Samuel Ogle, a British cavalry officer, imported the English bloodstock from which almost all American thoroughbreds are descended. Ogle staged the first thoroughbred races at the course in Annapolis in 1747, where the straight track ran down a portion of what is now West Street; George Washington ruefully noted in his journal that he'd lost quite a sum betting on his horses in an Annapolis race.

This civilized life was bought at a terrible price: much of the wealth of early Annapolis was created by the profitable trade in tobacco and slaves. Maryland's businessmen invested heavily in trade, and as the tobacco plantations expanded, the desire for cheap labor to work the crippling hours in the fields led to an explosion in the slave population: by the mid 1750s, 40 percent of Maryland's population was African.

Until Baltimore was made an official port of entry in 1780, Annapolis was the busiest harbor in the Maryland colony. Connected by a web of roads and rivers to a variety of destinations, the city was a transshipment point for a number of goods, including Africans who survived the terrible "middle passage" to arrive as chattel in a new land. The ancestor of author Alex Haley, a young Mandinka named Kunta Kinte, was sold into slavery on the docks of Annapolis in 1767; the account is related in Haley's massive family story Roots: The Saga of an American Family (Vanguard Press, 1976).

But the city did not deal wholly in slaves: all manner of goods were shipped in and a lot of tobacco was shipped out, as well as other agricultural

products. A variety of trade goods (including a lot of rum) arrived on ships that flew flags from around the world. Some of those ships came into harbor as legitimate vessels flying a national flag that came down once they were back on the water and preparing to attack—to be replaced by the Jolly Roger that declared the crew to be pirates!

Pirates were the scourge of the Chesapeake and eastern Atlantic, and while famous pirate sea captains cruised in large ships staffed by professional fighters, most Chesapeake pirate bands operated flotillas of small ships that could surround and cut off coastal schooners moving toward Philadelphia or south to Yorktown. Pirates also raided fishing villages, small settlements and isolated manors; the island communities of Tangier and Smith suffered frequent attacks, losing not only goods but also women to the water-borne marauders. Some of the women went willingly—particularly indentured servants and slaves seeking a better life (they were quite disappointed), while others were carried away from husbands and children. Edward Teach, who may be better known under his sobriquet "Blackbeard," was a frequent visitor to Annapolis, as was Captain William Kidd and the female pirates Anne Bonny and Mary Read; pirate treasure is said to be hidden away on Gibson Island, to the north of the city.

Both pirates and smugglers contributed to the flow of contraband that crept into Annapolis under the cover of darkness, or through narrow and dripping tunnels beneath the warehouses by the docks. After fencing their goods, the miscreants would take their profits and vanish into Hell Point, which occupied the spit of land now taken by the United States Naval Academy. Renowned for its sleazy drinking establishments, brothels and dangerous alleys, the Point would suck the profits of the sale from their pockets and send them poorer back to sea.

In the years leading up to the Revolutionary War, Annapolis seethed with conflict between Loyalists and Patriots, and arguments over representation and taxation were continuous, leading to the burning of the brig *Peggy Stewart* and a portion of her cargo on October 19, 1774—an act that became known as the Annapolis Tea Party. A local group known as "The Sons of Liberty" met by moonlight beneath a massive tulip poplar on the King William School campus that was ever after known as "The Liberty Tree."

During the years of the American Revolution, Annapolis was detached from much of the action, although French troops under the command of General Lafayette did make an encampment along the banks of

College Creek for several weeks. While battles were fought in Virginia, Pennsylvania and Delaware, British ships moved troops north and south along the Chesapeake and seldom set a foot in Maryland, although the Royal Navy did attempt to seal harbors and block shipping (with minimal success among the shallow tidal marshes).

When the war came to a close, Annapolis was chosen to serve as the first peacetime capital of the new United States, pending the ultimate move to the District of Columbia, and Congress was in session at the partially completed statehouse from November 26, 1783, to June 3, 1784.

The years following the Revolution saw Annapolis dwindle as a center of commerce, and the city was of minimal importance in the War of 1812, where its principal contribution came as a resupply and shipbuilding center. Probably the most famous military clash in Maryland came in Baltimore, where Fort McHenry came under attack by British warships; from the porthole of his prison ship in Baltimore Harbor, Francis Scott Key observed the attack and penned the poem "The Star-Spangled Banner," which was later set to music and named the national anthem of the United States. The British also attempted a landing south of the city but were repulsed in what became known as the Battle of North Point in 1814.

By 1820, Annapolis was a backwater, enlivened only by the ninety-day legislative session and the occasional antics of St. John's students. The United States Naval Academy was opened in 1845 on the site occupied by Hell Point, which had become a sad, dilapidated shadow of its former self. Although connected to the expanding seaport metropolis of Baltimore by rail, Annapolis remained a small town until the outbreak of the Civil War.[2]

The town's central location during the war years was key to the erection of a prisoner of war camp named Camp Parole to the west of the city and to large hospital facilities that served not only Union but also Confederate troops. Injured soldiers from battles in Virginia and Maryland were moved by ship and by rail into the city.

After the Civil War ended, Annapolis slipped back into nearly ten decades of quiet living. The world wars changed the city in small ways as the Naval Academy expanded and the Naval Research Center opened across the Severn, but true expansion began in the late 1970s and modern Annapolis is no longer an isolated state capital.

Today's Annapolis owes its wealth of early colonial and American structures to the better harbor of Baltimore just twenty-six miles away:

without it, Annapolis would have continued as a port city, warehouses and financial districts would have crowded the downtown and the quiet charm of what remains largely a colonial town would have been lost forever.

Instead, the Ancient City drowses on the banks of the Severn on humid summer afternoons and tucks its brick-trimmed arms about itself when winter closes with biting winds and fierce ice, bearing the passage of time with grace and beating with a heart still in tune with the rhythms and dances of the past.

CHAPTER 1

THE MARYLAND STATE HOUSE

THE AGGRIEVED GHOST OF THOMAS DANCE

A nnapolis is a city that rises from the waters of the Severn River and Spa Creek in a clutter of houses and streets, and capping the landscape is the Maryland State House. Built upon the highest point in town, the capitol building has an eighteenth-century heart and a modern digestive system; the historic chambers of the 1772 building grew too small to handle the growing number of state senators and delegates, and new chambers were added to the western side of the building in the early twentieth century. Seen from the east, however, the building appears entirely of the late eighteenth century, with a severe Georgian red-brick facade, a portico of marble blocks and Corinthian columns and symmetrical windows. When it was designed in the 1760s, this statehouse was to demonstrate that Maryland was a colony of civilized men, and it was filled with touches that spoke of culture and an understanding of classical design. They were even supposed to have used mysterious ratios and proportions in measuring the rooms and placing doorways, and there have always been rumors of secret chambers and storage spaces that were placed in the building for reasons conspiracy theorists can only imagine.

The building is actually the third capitol to stand above Annapolis; the first lasted less than a decade before it burned to the ground in 1704, and the second was a dilapidated mess by the middle of the 1760s. Construction on the new capitol began in 1772 but was interrupted by the outbreak of the American Revolution. The designer, Joseph Horatio Anderson, topped his statehouse with a cupola when it was finally finished in 1779.

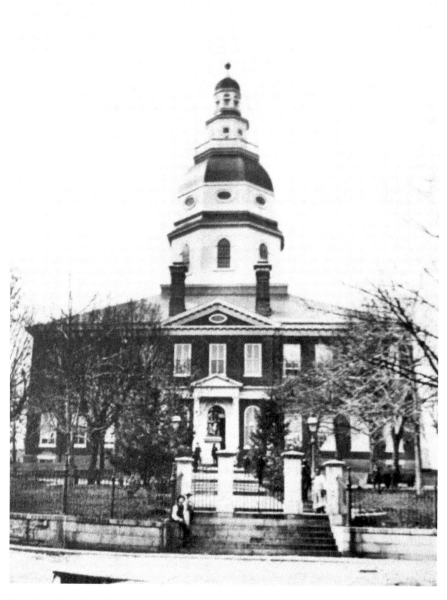

The Maryland State House, shown here in the 1880s, was placed on the highest ground in Annapolis and ultimately crowned with a dome that rises nearly two hundred feet into the air. Until 1996, the building was protected by the Franklin lightning rod installed in 1793, the metal rod covered by a copper-sheathed wooden acorn. A common decorative element in the late eighteenth century, acorns symbolized stability—to be "sound as an acorn" meant something was without flaw. *Courtesy of the Historic Annapolis Foundation.*

The cupola looked unimpressive on top of the massive structure, and the large roof developed numerous leaks; those working in the building suffered through the rest of the war, waiting for peace to come so they could afford to repair the problem.

A new architect, Joseph Clark, designed a soaring wooden dome to crown the building, but construction on the ambitious project was delayed for eighteen months after the end of the Revolutionary War while the Maryland State House served as the first peacetime capitol of the United States of America. The structure is the only state capitol that ever functioned as the nation's capitol, and legislative sessions have continued uninterrupted since the building was opened in 1772. Congress ratified the Treaty of Paris, which ended the war and recognized the United States as a sovereign nation, here in January 1784. George Washington tendered his resignation as commander in chief and delivered his emotional farewell address from the Senate chamber just before Christmas 1783.

Once the national capital had formally moved to New York City, preparations began for the construction of the dome. To their dismay, the builders realized that the cost for building the dome was going to be much larger than expected, due to the high cost for the nails they'd been planning to use in its construction.

Manufactured goods like nails and pins were imported from England, but prices were high and their one-time overlord levied export tariffs on goods. There was great reluctance on the part of the Maryland legislature to appropriate money that would line the pockets of English manufacturers, and there was no domestic company that could make them in the quantity needed. It seemed that there were only two choices possible: build the dome and absorb the cost of the nails or delay the project until a cheaper supplier could be found.

The architect and builders came up with an even better solution: they devised a way of building the dome without using a single nail. Held together with a variety of wood joins, wooden pegs and iron bands, the dome (which is actually two wooden cups nested together) was completed in 1794. Two hundred years and two major earthquakes later, the dome is a masterpiece of engineering that flexes in the wind, expands and contracts as the temperature and humidity fluctuate and has never required structural repair.

The ghost who haunts the statehouse is that of a man who died while working on the dome. Thomas Dance, a skilled plasterer, was on a scaffolding eighty-seven feet above the floor when he plunged to a horrible death on the

marble tiles below. No one knows if he overbalanced or if his equipment failed or if there was a push administered by a fellow worker, but eighty-seven feet onto a marble floor is an accident no one survives and his spirit haunts the building to this day.

Mr. Dance is a ghost with a grudge. Following his accident, his widow and children were forcibly deported from Annapolis to England and cruelly deprived of any pension that might support them once there. The perpetrator of these acts is said to have been the contractor on the building project, for reasons that are lost to history. Thomas Dance lingers in the shadowy corners of the historic rooms and hallways, hoping to make his grievances known.

Over the decades, there have been many sightings of a man in attire from the late eighteenth century who appears to favor the dome gallery and exterior balcony, although he has also been seen elsewhere in the building. Security guards report frequent false alarms that send them running from one end of the building to the other. Tourists often approach guards and staff to inquire about the identity of the man they had spotted up in the dome gallery wearing historic garb, many indignantly reporting that the man was shamelessly breaking the law by smoking a pipe.

The statehouse is subject to sudden drafts of ice-cold air that blow loose papers or lightweight objects from desks, and there have been many reports of footsteps echoing in empty hallways, doors opening or unlocking and objects moving or being observed to float and more than a few people who merely say, "I know I was not alone." Legislative staffers and volunteers have also had many stories to relate—from altered tallies on the voting boards to ringing phones and pitchers of water that suddenly fall over and play dead. For those who have worked in the building, the phrase "It's just Thomas" is one of reassurance—it's not an armed intruder, it's just the ghost!

Thomas Dance appears to feel a connection to the dome itself, perhaps because he died applying the finishing touches to the beautiful plasterwork that adorns its interior, and he has reacted dramatically to those who say or do something that angers him. Most of those stories include mention of someone intentionally causing damage to or speaking disparagingly of the dome, which is the point at which Mr. Dance makes his presence known.

In July 1997, a group of tourists on a historical tour of the building paused inside beneath the dome to listen to their guide. One of the gentlemen on the tour was less than impressed at what he saw above him and made a comment to that effect. The response from the ghost came a second later: a blast of freezing wind rattled the window embrasures, sent loose debris

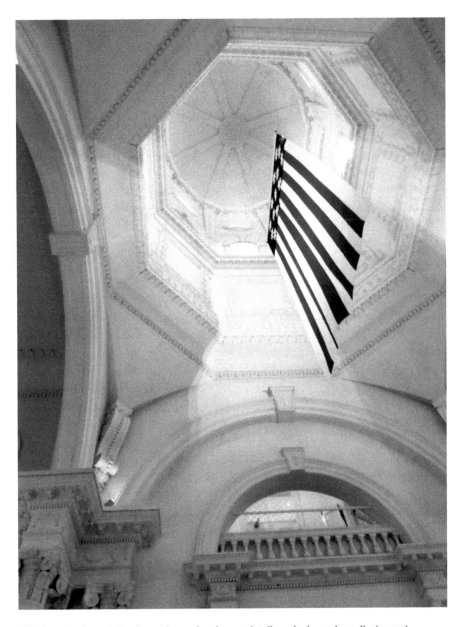

This interior shot of the dome shows the elegant detail work about the galleries and balconies, with the dome itself rising a dizzying 113 feet from the floor. The thirteen-starred flag is a replica of that made by John Shaw, the principal caretaker of the statehouse, at the direction of Governor Paca in 1783; the flag was probably first raised to honor the president of Congress, Thomas Mifflin, in December of that year when the building began its tenure as America's first peacetime capitol. *Rob van Schadewijk.*

flying and slammed open the wooden doors at both ends of the main hallway, sending papers out onto the lawn and staircase. One of the security guards on duty timed the incident at about ten seconds in duration, though some of the shaken tourists claimed it lasted much longer. When the gust of air subsided, they found the opinionated gentleman facedown on the floor. Several approached him, thinking he had fainted, but before they could reach him, the man leapt to his feet and bolted out the door, leaving behind a spreading puddle on the marble tiles and a cautionary tale to any who would disrespect Mr. Dance's plasterwork!

Visitors need not enter the statehouse to get a glimpse of its resident spirit: Mr. Dance has frequently been spotted on the balcony that circles the crown of the dome. He is often described as leaning on the railing of the eastern-facing side, his head topped by a cocked hat and what appears to be a long-stemmed pipe in his hand.

On an autumn evening in 2007, a tourist approached the Ghosts of Annapolis tour kiosk to ask a question about the statehouse. He'd visited it earlier that day, and the guide who had led his group through the building had told him that the interior dome gallery and exterior balcony were not open to the public. But later that day, when he was walking past at 8:00 p.m., he'd glanced up to see a gentleman strolling the circuit of the balcony while enjoying a pipe and the evening sunset; the figure was dressed in eighteenth-century garb, with a cocked hat and a long queue of hair dangling down his back. He'd fumbled for his camera, wanting to take a picture of this historic gentleman atop the historic building, but by the time he'd gotten it out, the man was gone.

The tourist wanted to know if he'd been misinformed by his statehouse tour guide; Mike Carter, the owner of Ghosts of Annapolis, told him that the dome was definitely closed to tourists and casual visitors…and that what he'd probably seen was the ghost of a man dead more than two hundred years. After hearing the story of Thomas Dance, the tourist went sadly away, lamenting his lost photo opportunity.

Before the last tour departed on that evening, Mike suggested to the guide and group that they take extra photographs of the dome and keep a sharp eye out for anything unusual; the group looked up at the statehouse from State Circle and caught sight of the same man described by the earlier tourist, even capturing a blurry photograph of a man in a tricorn hat leaning on the balcony railing. On the next night, a different guide and a different group saw the exact same thing. Carter went to interview the security staff at the State House to see if they could identify the figure—after all, if there was a historical reenactor in the building, that could explain everything!

The General Services Police supervisor said that the last time anyone had been out onto the balcony was a few weeks earlier, when they'd raised the flag back from half-staff (it had been lowered following President Ronald Reagan's death) and that it was impossible for anyone to have been out there, because no one on the night staff had access to the keys.

Since that night, Carter says, he has been unable to walk past the dome without looking up, hoping to catch his own glimpse of old Thomas Dance, smoking his pipe and pondering new ways to make his grievances known.

CHAPTER 2

GOVERNMENT HOUSE

REVERDY JOHNSON TRIES HIS LAST CASE

S ituated between the wheels of Church and State Circles, the grounds of the mansion that is the official residence of Maryland's governors are outlined by a black iron fence topped with imposing spikes. Built in the 1870s in a Victorian style with a mansard roof, Government House was substantially remodeled in the 1930s into a Georgian mansion[3] and has played host to countless prominent figures throughout the years. One of them apparently enjoyed the hospitality so much that he remains to this day.

Born in Annapolis on State Circle and educated at St. John's College, Reverdy Johnson was a lawyer and conservative Democrat best known as the counsel for the defense in the famous 1857 case Dred Scott v. Sandford, in which he represented the slave-owning defendant. He also served as attorney general for the United States in the administration of Zachary Taylor. Personally opposed to slavery, Johnson played a key role in keeping Maryland on the Union side during the American Civil War and later was elected to the state's House of Delegates (1861–62). He took a seat in the United States Senate in 1863 and, while a senator, defended Mary Surratt before a military tribunal on charges of plotting and aiding in the assassination of President Abraham Lincoln. The trial ended in her execution.

In 1868, President Johnson (no relation) appointed him minister to the United Kingdom, where he served until Ulysses S Grant became president. Mr. Johnson came home and resumed his legal practice, at one point prosecuting cases against the Ku Klux Klan.

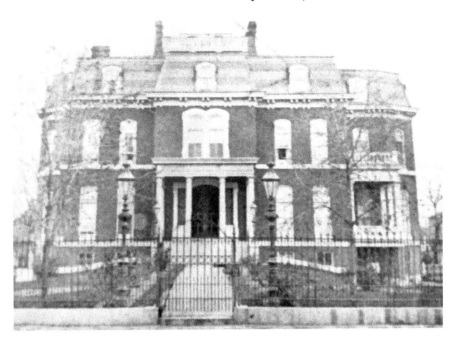

Originally designed as a Victorian-style mansion, Government House faces College Avenue in this photograph from the mid-1880s. Below and to both sides of the main entrance are tradesmen's entrances to the cellars; Reverdy Johnson stumbled over the low wall and fell into the one at right, striking his head on the wall and coping at the bottom. His companions pulled him out onto the lawns, where he died moments later. A fountain now occupies the site of his death. *Courtesy of the Historic Annapolis Foundation.*

In February 1876, Reverdy Johnson was in Annapolis to argue a case (*Baker v. Frick*) before the Court of Appeals and stayed at the mansion at the invitation of the newly inaugurated Democratic governor, John Lee Carroll. On February 10, Carroll hosted a reception for the legislature's members, their ladies and the assorted luminaries of Annapolis at which Johnson was the honored guest. As the evening progressed from dinner to dancing, the reception rooms became stuffy and many of the guests spilled out onto the grounds of the mansion for a breath of cold winter air. The *Maryland Gazette* reported:

> *On the evening of February 10th, 1876, when in his 80th year, with a mind yet undimmed by mental incapacity, and a body that gave promise of many years of usefulness, he [Reverdy Johnson] met with a fatal accident at Annapolis. He was at a social gathering at the Executive Mansion, John Lee Carroll being then Governor and host. Mr. Johnson started to go out*

*the main doorway. He was offered assistance but refused it. Passing down
the granite steps of the front porch, he turned to the left of the entrance and
fell into a paved area, five feet below, where he was found shortly afterward
in an unconscious state. He expired soon after being discovered. He died
almost within a stone's throw of the house in which he was born, and well
nigh under the shadow of his alma mater.*

News of the accident swept through the party, and music and laughter
gave way to disbelief and sadness. The body was carefully removed. Reverdy
Johnson was at Green Mount Cemetery in Baltimore two weeks later, with a
crowd of distinguished mourners about his grave.

Governor Carroll was one of those who attended the funeral, and when
he returned to Government House, he was to hear accounts from staff
and visitors about strange noises and ghostly encounters with the recently
deceased legislator. People spoke of seeing a man in fancy dress clothes on
the lawns near the building, of hearing music and voices within the reception
rooms and of strange lights and aromas in empty rooms. The sightings
continue into the present day.

The anniversary of his death appears to have some special significance
for Mr. Johnson, and February tenth is frequently punctuated by bizarre and
unexplained events, so much so that the staff at Government House have a
superstition about hosting parties or receptions on that date. Rumors and
whispers from the late nineteenth century hint at the disappearance of folk
whose last known location was on the grounds of the mansion on that date
(although research has failed to uncover any actual disappearances), and it
is certain that Johnson's ghost is more active in the weeks around the date
of his death.

General Services Policemen (GSP) regularly experience moments when
the guard dogs that patrol and protect the property will balk at entering the
rooms in which the party was held. If forced in against their will, the dogs
will whimper or bark until they are allowed to leave. An animal psychic
who was visiting the mansion improbably claimed that the dogs were merely
being tactful, not wanting to invade a party to which they were not invited—
when anyone who has ever owned a dog knows they don't need an invitation!
Whether they are being polite or are simply nervous, there are some days
when the dogs just don't want to go into those rooms.

Residents and visitors in the house have heard chamber music, voices in
animated conversation, the clink of cutlery on china and the quick whisper
of laughter in an empty room. A young man staying overnight at the

mansion in the 1990s reported passing a closed door late in the evening when he heard sounds of music and laughter from behind it. Convinced he was overhearing a movie soundtrack, he opened the door and looked into the room to find it dark and untenanted. Confused at the sudden silence, he stepped back from the open door and went into the kitchen for a snack; on

The rear lawn of the Governor's Mansion, viewed from State Circle. Employees and guests have reported hearing the sounds of revelry, laughter and music coming from the reception rooms that stand to the left of the building. *Courtesy of the Historic Annapolis Foundation.*

his return to his bedroom, the door was once again closed and the sound of music and voices came faintly into the hall. Hastening his steps, he went back to his guest room and locked the door.

Perhaps the best story comes from a member of the housekeeping staff who had just returned from a vacation when she had an experience that made her wish for another. She came to work one evening and was walking past the doors to the reception rooms when she heard the sounds of music and laughter on the other side. She was surprised to find a party taking place—no one had told her about it—and decided to poke her head into the room to see how large the group was and what sort of cleanup would be required. To her great amazement, the room was filled with men and women in elaborate historical dress who were dancing and talking, the air was filled with the fragrance of wine and roast meat, hot candle wax and crushed flowers, but the aroma that most caught her attention was that of sweaty human bodies, a scent modern Americans don't encounter very often. At first thinking that she was interrupting a special event (the governor hosts several events throughout the year that feature people in historic dress), the housekeeper pulled the door shut and started down the hall. As she was walking toward the kitchen, she realized that there was none of the bustle she'd expect in the hallway if a party were taking place, and she returned to the room to find someone who could explain what was going on. But when she opened the doors a second time, the room beyond was silent and utterly empty.

On another occasion, a housekeeper at the mansion was washing windows in a second-floor room when she looked down at the gardens below where an elaborate pineapple-crowned fountain had just been installed. To her shock, standing knee-deep in the fountain was a heavy-set man in elaborate historical clothing, looking about with interest as he quaffed something from a large pewter tankard. The housekeeper ran down the stairs and outside, but when she made it to the fountain, water was splashing into the air and down into the basin without interference: the man was gone.

Motorists driving past the mansion frequently contact security staff to report a shadowy figure standing in the fountain, a figure that has been known to raise his glass as if to offer a toast to a passing traveler.

CHAPTER 3
ST. ANNE'S CHURCH
JOE MORGUE WOULD LOVE TO DIG YOUR GRAVE

B uilt on the second highest point in the city, St. Anne's red-brick walls
and stained-glass windows are shaded by magnificent elms, willow oaks
and sycamores. Its grounds are girdled by an iron paling fence, and sidewalks
separate it from the bustling traffic of Church Circle. It is a small island of
peace in downtown, and many people visit the church building outside of
service hours to admire the beautifully carved wood and stained glass or
wander the grounds to read the inscriptions on the few grave markers that
remain in the cemetery.

The present church, built in Romanesque revival style, is actually the third
structure to occupy this site. The first St. Anne's was erected between 1696
and 1704 and torn down in 1775 to make room for a larger one that, because
of the Revolutionary War, was not completed until 1792. A devastating fire
on Valentine's Day 1858 destroyed all but a portion of the bell tower that
was incorporated into the new church that rose in 1859. The building is an
active church of the Episcopal diocese of Maryland, and the congregation
still uses the silver communion service given to the church in 1695 by King
William III and possesses most of the historical parish records and prayer
books, including one purchased in 1764 that contained a prayer for the
president of the United States written in ink to replace the printed one for
King George III.

The cemetery in the circle does not appear to contain many graves, but
appearances can be deceiving: many of the markers are not stone boxes that

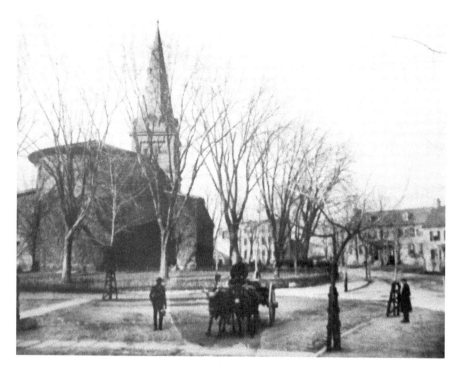

The current St. Anne's was constructed after a catastrophic fire on Valentine's Day 1858. The grounds about the church were the only consecrated burial place in Annapolis for many years and despite the lack of tombstones, the dead lie thick beneath the sidewalks and street. *Courtesy of the Historic Annapolis Foundation.*

contain a single burial but openings that lead to family sepulchers that could contain between six and eight adults and any number of infants and small children. The wood and sedimentary stone markers for other graves were destroyed by time or demolished in the catastrophic 1858 fire, leaving many burial plots marked only by grass. Some bodies were relocated to the newer St. Anne's cemetery by College Creek when the expanding streets began to encroach, but others remain beneath the wheels of traffic and the feet of pedestrians. It was estimated in the early twentieth century that the graves extended beneath the streets to Government House and the Annapolis Post Office, and any work done in the vicinity of Church Circle invariably turns up artifacts.[4]

If a St. Anne's parishioner died between the years of 1750 and 1835, he or she was most likely consigned to the earth by Joseph Simmons, sexton at the church for an astonishing eighty-five years. An obituary published by the *Annapolis Republican* in 1837 was nearly half a page in length—a tribute

to Mr. Simmons's long service to St. Anne's, as well as a last opportunity to discuss the eccentricities that made him locally infamous.

In all his long life, only one person commanded Joseph Simmons's respect and affection: Colonel George Mann, in whose eponymous tavern on Conduit Street George Washington spent the final night of his military career and the site of the Annapolis Convention in 1786. Simmons served the colonel as his steward for many years, overseeing the purchase of supplies for the tavern and keeping the accounts. The obituary mentions that the only time Simmons wept was at Mann's internment and ends by noting: "Amidst the many peculiarities of character that distinguished the deceased, some of which no doubt grew out of an occupation that seventy or eighty years had made perfectly familiar to him, though spoken and even thought of with a strange superstition, awe and aversion by some 'grown up children,'—amidst all his peculiarities we say, none were more distinct than his strict veracity, honesty, and sobriety."

"Peculiarities of character" was a polite way of referring to some of Joe's less attractive qualities, and his "strict veracity, honesty and sobriety" were probably what kept him employed in spite of them.

It was said that he was rude and brusque to all who breathed, preferring to lavish his attention on those who no longer could, and he loved digging graves and burying people. On days when there were no fresh applicants for residency, it was common to see Joe out in the graveyard digging someone up so that he could have the pleasure of recommitting him or her into the ground.

Although he had ample means, Joseph Simmons wore the clothing of a pauper, and he had no liking for soap, razor or hairbrush. In his later years, the long white beard (liberally stained with tobacco juices) and tangled disorder of his hair made people think of a dirty Father Time.

Among themselves, townspeople called him "Joe Morgue," and their children—not knowing it was a macabre nickname—would politely address him as "Mr. Morgue," sending him into a froth of rage. He would advance on the cowering children, shaking his fist and shouting that he'd have them in his hands, someday! Under cover of night, he was said to dig surreptitious child-sized graves in the yards of those whose offspring had particularly insulted him. Any adult who offended him could look forward to whispered abuse from the old man when he passed on the street: "I'll have you someday!" he'd rasp menacingly, following the promise with an ominous chuckle, as he'd shamble away. He was said to have an eye for a pretty woman, though; on one occasion he delayed the ringing of the one o'clock bell so a tardy wife could make it home in time for lunch with her punctilious husband.

One of the more macabre incidents in his life was mentioned in his obituary in the *Republican*:

> *A man named Jeffrey Jig, who lived with his wife Ginny Corncracker in a little house at the base of Duke of Gloucester Street that was so small neither could stand upright within it, had been thought to be dead many times, as he had a habit of falling into death-like comas. His funeral was scheduled and cancelled several times before he fell into a coma that lasted three days, leading his family to conclude that he was finally and truly dead. Once again, Joe Simmons dug a grave and this time, the funeral was held and Jeff's body consigned to the earth.*

At the conclusion of the service, the mourners left the cemetery. Joe began to fill in the grave with heavy clumps of earth, and the clatter must have been what finally woke Jeff Jig from his coma. Sounds of muffled shouts and thudding blows from within the coffin summoned the mourners back to the edge of the grave.

In days past, it was not uncommon for people to be buried alive; studies vary, but a significant number of folks were placed in the earth because their vital signs were undetectable. The occurrence was so frequent (and the very thought so horrible) that many people took the step of having an alarm bell installed as part of their burial. The bell-pull went down a metal tube that screwed into the lid of the coffin, and if you had the misfortune to awake in the dark, all you had to do was fumble about until you located the bell-pull. Once the bell above started ringing, whatever person was working the "graveyard shift" would grab a shovel and start digging and hopefully make it there in time.[5]

In this instance, Jeff didn't need a bell to get peoples' attention. The crowd rushed back to the grave, realizing that there had been a terrible mistake. When they got close enough, they realized that Joe had not stopped filling the grave—in fact, he'd sped up and was pitching dirt into the hole in such a frenzy that the coffin had vanished from sight and all that onlookers could see was a pile of earth that shuddered and trembled as Jeff did his best to fight free of his wooden tomb.

Joe was wrestled away from the grave with great effort, breaking free several times to rush back and throw more dirt into the grave—even attempting to throw himself in, as if to hold Jeff down in his proper place. Finally immobilized, Joe watched, cursing and shouting as Jeff was rescued and helped from the coffin. "If he isn't dead, he damned well ought to be!" the

The section of the graveyard that lies on the western side of the circle is reputed to be the most haunted portion of it, with legendary gravedigger Joseph Simmons a frequent visitor. *Rob van Schadewijk.*

old man shrieked. There are anecdotal accounts that say Joe flatly refused to dig a grave for Mr. Jig when he finally met his end, on the grounds that he would undoubtedly come back and ruin that funeral as well.

Joe died in 1837 and was buried next to Colonel Mann on the banks of College Creek. While his ghost has been seen moving among the tombstones on the hill near his resting place, it is far more common to see "Old Joe Morgue" steadfastly at work on the grounds about the church. People have reported his unkempt figure commuting from his "home" and walking up Northeast Street toward Church Circle in the pre-dawn hours, presumably the start of his working day.

Parishioners and church staff alike have stated that on several occasions when they have entered the church early in the morning or late at night, they have found an old man sitting quietly in the back pew. Most assumed him to be homeless, having either broken in or been accidentally locked inside. If they approached him, he would scowl and rise to his feet to make a retreat to the door; few pursue him closely because of his unkempt and hostile demeanor, but they do follow to make sure he's left the building...

and are shocked to discover that he has vanished from the building without opening the doors.

As one might expect, he is most often seen working at his favorite pastime, shovel in hand. His shaggy beard and long loose coat cause most people to take him for a homeless person, and Annapolis police often receive calls about a vagrant digging on the grounds of the church. Needless to say, there is never any evidence of digging when the sightings are investigated, and no sign of an unkempt vagrant, either.

Local tradition says that seeing Old Joe Morgue is bad luck, and catching his eye is worse. If you lock glances with the old gravedigger, it is said you have only three days to live; just spotting him at work will ensure a broken leg or an extended visit from your mother-in-law or some other horror. Many Annapolitans will not walk past the western side of the circle (where he is said to be the most active) after dark, for fear of attracting his attention.

Ghost tour participants who visit the graveyard have experienced a variety of unsettling events, from streetlights that flicker at apropos moments in a guide's story to hearing whispers, seeing dancing lights within the empty church building and walking through cold spots.

The Ghosts of Annapolis tour guides have a ongoing relationship with the old gravedigger and can usually count on a greeting when they enter the graveyard—the streetlights go out and come back on—and several have heard a man's voice whispering their name. One guide claimed that she could hear Joe breathing next to her ear and that he would tug at her clothing. When another was giving a midnight tour of the cemetery on Halloween, her lantern light started to flick off and on.

The lantern was lit with a sealed chemical stick that glows as the result of a chemical reaction—something that cannot be turned off and then back on. When he consulted a chemical engineer, the owner of the tour got an unequivocal response: glow sticks can't do that. On other occasions, the glowing wristbands worn by tour participants have gone out with no warning (and do not relight) and cameras and other electronic devices malfunction or cease working altogether, only to return to normal function when the group has moved out of the cemetery.

Joseph Simmons is not the only unquiet spirit in the St. Anne's churchyard. Photographs, videos and audio recordings taken in the vicinity of the church have held images and sounds that were not apparent at the time they were taken. Images of a young woman in a white or light-colored dress from the period after the War of 1812 have been captured beneath the immense willow oak on the western side of the circle, and a guide on one of the

walking tours was photographed among the grave markers—in the resulting pictures, she was nearly completely obscured by ropes of fog that seem to outline faces and figures. Paranormal researchers have obtained audio recordings in which a variety of voices and accents can be heard, some even appearing to respond to the questions posed by the researcher.

So walk the hidden graves of Church Circle, read the monuments that still stand in the churchyard and step into the vaulted dimness of the church. In the shadows, Joe Morgue is watching.

CHAPTER 4

REYNOLDS TAVERN

IT'S A JOLLY HOLIDAY WITH MARY

In 1747, William Reynolds, a hatter and dry goods salesman, took a sixty-year lease on some property owned by the parish of St. Anne's. This "glebe land"[6] was located directly across the circle from the church on the corner of Franklin Street. Reynolds built a sturdy and attractive three-story building that housed not only his hat-making business but also an ordinary leased to Mary Fonnereau who operated it as Reynolds's tenant from 1755 to 1757. When her lease expired, Reynolds applied for a tavern license on his own behalf, to be known as The Beaver and Lac'd Hat and continued to operate the business until 1767. By 1770, he had returned to hat-making as his primary business, but people still gathered there to play cards, eat, drink, conduct business and socialize. The Mayor's Court and the Corporation of the City of Annapolis met regularly at the tavern, which was also a popular stop for legislators and visiting military.

William Reynolds lost his first wife in the late 1750s, and when he remarried several years later, it was a scandal to the town. Young, beautiful and a social nobody (prior to their marriage, she was reportedly working as his housekeeper), William's second wife, Mary Howell, provided only the best. Her finicky housekeeping meant that the rooms were spotless, with a smaller population of fleas and bedbugs than any other tavern supported, and the food and beer she served her customers was of the highest quality—no decomposing mice in the beer barrels, and no food-poisoning cases from spoiled goods. She was scrupulous about the

behaviors of not only her staff but also of her customers: Mary Howell Reynolds ran a respectable ordinary.

Mary had a reputation for being a canny businesswoman with a memory like a steel trap; she would remember details about returning customers (likes and dislikes, where their property was, what they were in town to buy or sell, to whom it might be helpful to introduce them, etc.), ensuring that every visit was tailored to their pleasure. Many customers came to bask in her attention, and not a few fell prey to her charms, but for all her ready wit and obvious beauty, Mary was a respectable woman who tolerated no liberties with her person or her reputation. Her admirers were doomed to disappointment.

Colonel George Washington was a frequent visitor to the Maryland's capital (he loved the horse racing and wagered enthusiastically, if not always well), and he is anecdotally said to have flirted a bit aggressively with the young woman on one occasion. The stories have Mary trapped by his drunken attention until freed by either her husband or by her own efforts, using a rolling pin as a cudgel to drive the intoxicated officer out of the building and down the street. While there are no contemporaneous accounts to verify the story, this legend has had firm currency in Annapolis for nearly two hundred years, and one can see why: the image of a younger "Father of the Country" running out of a tavern beneath a hail of blows from a rolling pin (possibly from a woman's hand) is irresistible.

William Reynolds died in 1777, and his will left the tavern to Mary and their daughter, Margaret (two sons still living from his first marriage were given monetary bequests). Mary ran the tavern until her own death from natural causes in 1785.

Her funeral was well attended, and the crowd adjourned back to the tavern following the service to drink to her memory and reminisce. An hour or two into the reception, a family member went upstairs to one of the bedrooms on the third floor, opening the door before letting out a scream and collapsing to the floor in a faint. When she was revived, she pointed into the room and said that she'd opened the door to see Mary sitting on the edge of the bed, fully dressed and smiling. Other sightings followed in the next few weeks, and it seemed that the renowned tavern hostess had settled in to keep a permanent eye on her business. Her presence in the building was widely accepted at the time—as it is in the present day.

Margaret Reynolds took over management of the tavern, but her husband, Major Alexander Truman, was not a very competent businessman, and his debts forced them to leave the property by 1788.

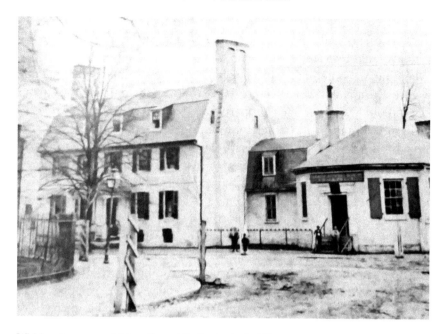

Within a few years of Mary Reynold's death, the building was no longer a tavern. Farmer's National Bank of Maryland used it as a residence for bank officers and general offices, and it was later adapted for use as a public library after nearly being demolished to make way for a gas station. *Courtesy of the Historic Annapolis Foundation.*

The tavern building eventually became part of Farmer's Bank and was used both as a residence and as offices. In 1936, the site was rescued from demolition (it nearly became a gas station) by local preservationists, and the building was used as the Annapolis Public Library until the 1970s, when the new library building was constructed. A string of businesses occupied the premises, none lasting for long, until the mid-1980s, when it was purchased and renovated by the Historic Inns of Annapolis, with much of the work focusing on restoring the original portions of the property to its condition when owned by William and Mary Reynolds.

Sporadic activities, noises and sightings had occurred throughout the years, with the legend of Mary Reynolds's presence for an explanation, but such activities became commonplace when the Historic Inns reopened it as a tavern.

The new managers discovered that they had an active, if invisible, assistant. Undoubtedly Mary, who was neither a banker nor a librarian, welcomed the opportunity to get back to work in her chosen career.

Her presence in the building is said to guarantee that the staff is kept on its toes—any task not done properly may bring a rebuke: a table improperly

set suddenly has the cutlery in a pile at the center to encourage staff to do the job again and a flower vase or water pitcher will spill across a counter or table insufficiently wiped clean. Staff members tell tales of finding the furniture set askew when they leave a room for barely a moment or glasses or plates breaking in the presence of certain employees that Mary appears to dislike.

Foul language is one sure way to get her attention; curse too loudly and too often, and it's said that she will drop things on you, knock furniture across your path and drench you in liquids from dishwater to beer to hot soup. Guests in the upstairs bedrooms have reported that lights flicker as if in warning when their language becomes loud and risqué—after a few warnings, the bulbs burn out with a loud sizzle.

As an efficient manager with a keen eye on the bottom line, Mary Reynolds works hard to deter workplace theft. Over the past three decades, employees trying to leave with purloined items have been exposed as a backpack or purse suddenly fell to the floor and burst open or when a pocket's stitching abruptly gave way to drop something onto the floor. From frozen filet mignon to a wallet stolen from a coworker, to hidden cases of beer or drug stashes, Mary tries to stay on top of it all.

Customers who become too intoxicated or obnoxious come to her attention as well. She first attempts to shame them into going home, often by spilling a drink directly into the patron's lap. If having a large and very wet stain there does not sufficiently embarrass them into leaving, she will knock over any other alcoholic beverage that they attempt to drink, jostle their chair or stool, discomfort them with cold drafts and make them as uncomfortable as possible. At a last resort, if they are completely impervious to these pressures, she will wait until they visit the restroom and then lock them in. Drunken customers have been trapped in the bathroom for up to thirty minutes, although generally it takes far less time for her to make her point, and after fifteen minutes of being publicly trapped in a toilet, most people do take the hint and go home.

Mary's presence in the building has lighter moments, as when she "borrows" a cookbook or trade magazine; staff enter the building to find the missing volume set out on a counter or table. She's been known to move spices and other ingredients together on a counter, as if to encourage their use in a recipe. Many have reported hearing a cheerful whistle outlining an unfamiliar tune in or near the kitchen or a woman's voice singing in the stairwell, particularly around the Christmas holiday, said to have been Mary's favorite time of year.

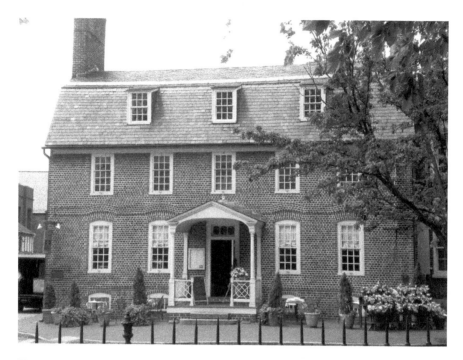

The modern Reynold's Tavern has been meticulously restored, with many original interior fixtures and structural details intact. The basement tavern, with its wide fireplace and warming ovens, lies farther below street level than originally; the window embrasures have been altered to accommodate the new height. *Author photo.*

Reynolds Tavern is currently a bar and restaurant that offers lodging, with the pub in a basement stripped down to its 1747 bones to reveal the ancient lineaments of the tavern Mary ran so long and so well and where she continues to oversee operations into the present day.

CHAPTER 5

RAMS HEAD TAVERN

FLIRTATIOUS AMY AND ELUSIVE SOLDIER

The two-and-a-half-story brick building that stands at 31–33 West Street currently houses part of the Rams Head Tavern, a chain of interconnected buildings that grew from a small basement pub into a restaurant and entertainment venue that lines a third of the block.

Built between 1831 and 1849, the building was designed as a combination of commercial and residential spaces, with the interior divided into separate parts: on the west, a side-passage plan served as a dwelling with a basement tavern space and, on the east, a storefront on the ground floor with a family apartment and attic above. Both of these spaces served as taverns for at least some of their history, and the cool stone and brick basement and creaking wood floors are filled not only with the hungry living but also with the restless dead—among them a young woman named Amy and an anonymous Civil War infantryman.

Amy was the lively daughter of a widowed tavern-keeper whose establishment occupied the basement of the western portion of the building around the time of the Civil War. Annapolis rumor said that the serving girls at this tavern sold more than just beer, and the rumors were true—soldiers and sailors were not the only men to seek refreshment in the widow's cozy taproom, but they were the most frequent.

The stories say that Amy took a young man to her room above the bar early one evening. Shortly after they disappeared upstairs, the round wooden chandelier in the center of the ceiling began to sway back and forth with

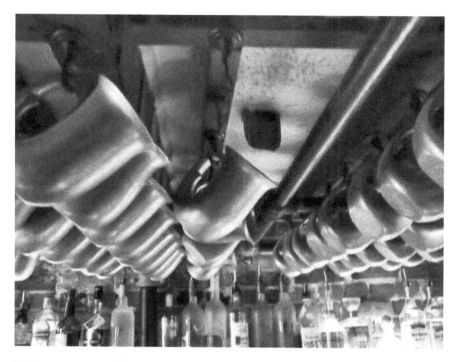

Hidden among the pewter mugs and close-set beams, the leg of Amy's bed juts through the plaster of the ceiling. *Rob van Schadewijk.*

increasing agitation, eliciting drunken cheers and bawdy comments from the bar patrons. But their jests turned to shock as large pieces of plaster began to fall from the ceiling, and they hastily took shelter beneath tables as the timbers above groaned and finally gave way and the furnishings of the room above came crashing down into the tavern.

Had the bed fallen cleanly through the floor, its occupants would most likely have been uninjured, but one of the legs of the bed frame punched through between two beams and the rest of the frame snapped, throwing them into the wreckage; the young man's injuries were serious, but he survived. Amy was not so fortunate: the violent impact with the floor snapped her neck, and she died instantly. Not only did her spirit remain behind to haunt the tavern but modern visitors who look closely between the pewter tankards that hang from the beams above the bar can also see the leg of the bed poking out of the ceiling plaster.

The restless ghost of the popular tavern wench has a hunger for male companionship that cannot be satisfied, and her "flirtations" with male customers are legendary. On several occasions over the last few decades,

ghost-hunters and paranormal investigators have chronicled events where a particular man in the group has been singled out for Amy's special attentions, and there are many similarities. In all cases, a measurable "cold spot" that was as much as forty degrees cooler than the ambient room temperature was detected, and the man in question reported feeling as though light fingers were stroking his hair or face, with some men reporting a strong scent of rose perfume or a breathy, teasing laugh against their ear. If the gentleman already has a companion, that unfortunate woman may suffer a variety of indignities—from being drenched with beer to having a chair tip over backward—events orchestrated to drive her away from the object of Amy's desire, leaving him vulnerable to the girl's practiced wiles. But Amy is a fickle flirt with a short attention span; after a few moments of intense cold in which she gives "frigidity" a whole new meaning, she's off to the next man or on to the next bit of mischief.

As the Rams Head has expanded into other buildings on the block, Amy's territory has encompassed those new spaces. Construction workers renovating the basement that would become part of the brewery locked up one night after completing the wooden framing that molded a concrete-covered support beam. When they returned to remove the framing, they discovered that someone had written a name in the now-cured concrete, and the lead contractor was furious but confused. An investigation revealed that no one had entered the locked area, and there were no current staff members who had the name etched in the cement: Amy. The writing was done as if by a stylus or sharp stick, and the characters are straggly and uncertain, with the "Y" printed in reverse—about what you would expect from an unschooled tavern girl.

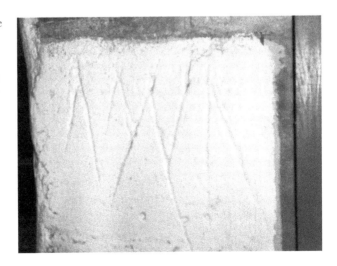

Workmen removed the wooden forms they'd placed to construct a support pillar to discover that someone had scratched the wet cement with a sharp object, scrawling letters that seem to spell "Amy." It was later established that no one had been in the area (the building had been locked up over the weekend), and there was no one on the staff by that name. *Author photo.*

It appears that Amy doesn't like women: since the Rams Head opened in the 1980s, a steady stream of female employees have been the target of malicious tricks and unsettling episodes, all attributed to the ghost's presence in the building. Bartenders, servers and kitchen staff report things moving unexpectedly, equipment turned off or on, plates and trays that do not fall but are pushed or jostled, furniture that is abruptly relocated and the sounds of laughter and footsteps.

DiDi Dolan, a manager in the 1980s, was closing down one evening with another employee when a series of disruptions occurred: chairs set on tables kept falling to the floor, the phone rang over and over with no one on the line when they picked up and, as Ms. Dolan described, "Suddenly, we heard the calculator going off. The total button was being hit over and over again, and the tape was scrolling out the back." When the two went over to turn it off, they realized that not only was the switch set to the off position, but the calculator was unplugged from the wall socket. As they looked at each other in confusion, both heard a breathy girlish laugh and were buffeted by a cold breeze scented with roses. They hastily turned off the lights, locked the door and went home.

Discussing it later, the employees decided that Amy's mischief toward the women was due to the lack of male companionship in the building (the small size of the business at that time required a closing staff of two or three), and on nights with an all-female closing staff, an informal arrangement sprang up whereby someone's husband or boyfriend would come in at closing time. He'd sit at the bar while the staff closed up, sipping on a beer and possibly borrowing a sweater, a distraction for the flirtatious tavern wench that would allow the female employees to get home on time.

Amy is not alone in haunting the building, but her paranormal companion is much less obtrusive. His identity is unknown, but he is very definitely a soldier—a Union infantryman from the descriptions of his uniform—and like so many soldiers, he enjoys sitting in a bar and drinking a beer. Employees and customers have seen his tall, blue-clad form walking down a hallway in the direction of the taproom, and others have looked through a window to see him sitting quietly in a corner with a mug in front of him, his face shadowed beneath the brim of his cap.

The story that has come down to us is that this anonymous soldier died in his room at the Sign of the Green Tree after being discharged from the hospital to continue his convalescence in town. Perhaps his wounds became infected, or he fell victim to one of the many deadly fevers endemic to Annapolis in the warmer months, but he was found dead in his bedchamber one morning, and despite a military funeral and an honorable grave, he has

The side-passage that leads to the Tearoom of the Rams Head; a tall figure in the dark blue uniform of a Union officer has been seen walking the hall, and some have seen him standing within the Tearoom, next to the fireplace. *Rob van Schadewijk.*

not found rest. A persistent rumor at the Rams Head says that if you leave a beer unattended long enough in the room called the Tearoom, you will reach for it only to discover that someone else's thirst has been greater and more insistent than your own.

CHAPTER 6

THE HISTORIC INNS OF ANNAPOLIS

The three buildings that compose the hotel group known as the Historic Inns are the Maryland Inn, Governor Calvert House and the Robert Johnson House. While there have been reports of paranormal activity within the Robert Johnson House, we could find no information on the responsible parties, and the activity was not frequent or sustained enough to merit inclusion in this book. Fortunately, the other two buildings possess more than enough ghostly inhabitants.

THE MANY GHOSTS OF THE MARYLAND INN

Built originally as an inn, the four-story building at the top of Main Street is the oldest continuously operated hotel in the United States. Defined by the spokes of Main and Duke of Gloucester Streets, the flatiron-shaped property looks across Church Circle, its height just below that of St. Anne's clock-faced steeple.

The nucleus of the current building was constructed between 1772 and 1781 with an ell-shaped addition expanding it in the late nineteenth century. The modern Maryland Inn has thirty-nine bedrooms and suites, as well as restaurant, banquet and conference spaces. According to local legend, the building has more ghosts than any other in Annapolis, with at least one for every room in the building.

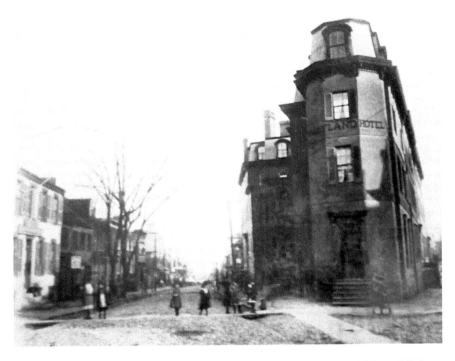

The flatiron-shaped building that houses the Maryland Inn is outlined by Main and Duke of Gloucester Streets. The oldest hotel in the country that was designed as an inn and still in use, the historic building has foundations that incorporate previous structures, such as the town drummer's lot. *Courtesy of the Historic Annapolis Foundation.*

The site it occupies at the top of Main Street contains the historic location of the "Drummer's Lot," the official location for the town's news crier, who used coded drum rolls to announce everything from a public proclamation to a pending vote in the statehouse. (Woe to the legislator who did not hear the warning—those who missed votes had to pay a fine: one hundred pounds of tobacco leaf.) A variety of small buildings occupied the lot until Thomas Hyde took over a ninety-nine-year lease on the property in 1772 and constructed a three-story building that he advertised as "one of the first houses in the State for a house of entertainment."[7]

Sightings of ghosts from every era in Maryland's history have been reported, particularly in the basement pub areas whose foundations predate the foundations of the inn.[8] With the town drummer situated at the top of the street, many small taverns operated in the lots now encompassed by the building, and glimpses of men in military uniforms and gear from the early eighteenth century are not uncommon. The western end of the building abuts Church Circle, and the basement area is currently occupied by a coffee

shop; visitors who look through the iron gate that closes off the old wine cellar at the tip of the property can dimly discern the outlines of a tunnel that opened into it. Theories abound as to where the tunnel might have led, with the statehouse and the crypt of the second St. Anne's church as leading contenders. Tunnels existed throughout historic Annapolis (primarily to facilitate smuggling), but the land was unstable and most collapsed and were filled in by the early nineteenth century. The tunnel in the inn was probably created by someone who had a need to make discreet entrances and exits and may have preexisted the construction of the 1772 building. Figures in ancient uniforms have been seen coming from the direction of the wine cellar, moving toward where the cozy taproom used to beckon with its promise of companionship and beer.

Employees of the inn tell stories of hearing voices in the empty dining room or catching a sudden and very strong whiff of pipe tobacco or finding objects moved inexplicably out of place. Visitors looking through windows frequently mention seeing items or people who were no longer there when they entered the building.

One of the most amusing ghost stories takes place in the women's powder room on the main floor. On a pub-crawl in 2010, five ladies were washing up and getting ready to move to the next haunted pub, when the door to the hall opened and the only thing that entered was a chill breeze. The draft blew one of the stall doors open, and a moment later, it swung closed and the five women heard the latch click shut. They stood, frozen, in front of the mirror, and for an agonizing time, nothing happened. They heard the snick of the lock opening, and the door swung wide; they shivered once again as an icy wind blew past to open the door to the hall, which closed slowly in its wake. Later, the women told the tour group that they "just didn't know what to do!" They were positive something had come into and then left the bathroom, but they had no idea where it was now, and they didn't want to walk through it because they'd heard stories in their childhoods about getting the breath sucked right out of your lungs if you walked through a ghost. After a strategy session in front of the sinks, the women each took a huge breath and held it as the group careened out of the bathroom, down the hall and out on to the front porch. Several other people have encountered this same bizarre haunting, and sadly, we have no idea who it is—but when one of the guides jokingly mentioned that the ghost neither flushed nor washed up, speculation was rampant that the spirit was a man!

Many of the guest rooms come with a ghost, and that's almost a guarantee if you are in one of the fourth-floor bedrooms. Legislators and military

personnel have taken long-term lodgings on that floor for over two hundred years, and a few of the rooms are efficiency apartments that currently house inn staff, many of whom report hearing voices and footsteps in the hallway, on the stairs and in some of their rooms, as well.

One of the most famous ghosts on the fourth floor is known only as the "Bride." According to local tradition, she came to Annapolis from North Carolina in 1817 to celebrate her wedding to navy captain Charles Campbell, an event long-awaited and long-delayed.

After proposing to his beloved in 1805 or so, Mr. Campbell went to sea, hoping to earn enough to return within a few years to settle down with her and live happily ever after on a farm of their own. Skilled sailors were in high demand in the opening years of the nineteenth century as the American shipping industry nearly doubled in size between 1800 and 1812, and the young man was intelligent and capable and was rapidly promoted.

Great Britain was at war with France during much of Campbell's early time at sea, and when British ships began stopping American vessels to search for deserters from the Royal Navy and to indict the shipment of goods to France (whose coastlines England did her best to blockade), the United States Navy began looking for more than a few good men—they started looking for a lot of them. Charles Campbell took a commission as an officer, and by the end of the war, he had risen to command of his own vessel, but such were the exigencies of war that he had no chance to come into port long enough to lead his bride to the altar. In 1817, he was released from service and wrote to his beloved, asking her to come to Annapolis to meet him. They would marry there, he said, and at last begin their life together.

According to inn lore, she immediately packed and left her small town to come to Annapolis, which in 1817 was a bustling and dangerous seaport—the stereotypical big city, certainly no proper place for a countrywoman on her own. But Captain Campbell had directed her, in his missive, to the inn; when in Annapolis, it was where he lodged, and he had written to ask the staff to take special care of his beloved. And so, under the benevolent attention of the staff, she took possession of his usual rooms on the fourth floor and settled in.

Some accounts have her waiting for weeks, others for mere days, and surely the truth lies somewhere between. Whenever her ship came in, its entrance into the harbor was noted and a message sent to the inn, where the staff gave her the news. She immediately changed into the dress she had sewn for this day, painstakingly embroidered and ornamented, asked the maids to help her with her packing and her hair and, these tasks completed, set herself to wait.

The ship came in near dawn, but the hours crept slowly past until it was the noon hour. Throughout the morning, the Bride's footsteps had tolled impatient rhythms on the wide planks of the wooden floor; unable to settle with the anticipated moment finally so close, she paced between the door and the window that looked down on Main Street. It was spring and the air was cool, but she would throw open the window again and again to lean on the sill, looking out and down the length of the crowded street. But her eager gaze never fell upon her beloved's lean figure; each time, the sash came down, and she would return to her restless walk.

In the early afternoon, one of the maids brought her a small meal and stayed to talk. Most of the staff were caught up in this geriatric love story: the Bride had to be at the least in her mid-thirties and was probably closer to forty in a culture where women were often married by sixteen and dead before forty. That she had waited for her beloved and he for her, well…it was just too romantic. Perhaps she was relaxed by the conversation with the maid, because the Bride no longer looked down at the street but gazed up into the sky. There was a sudden commotion below, and the Bride looked down and let out a shriek before racing from the room. The bewildered maidservant went to the window and saw that a horrible accident had occurred directly in front of the building: lying in the middle of the street was the body of a man wearing a naval uniform. When the breathless maid emerged from the building, it was to find a silent and horrified crowd encircling the immaculately coiffed and dressed woman whose arms held the body of her beloved, breathing his last in her embrace.

Witnesses said the captain had paused on the other side of the street, looking up at the building, and it is likely that he saw his beloved looking out the fourth-floor window because he broke into a broad smile and practically leapt into the street. Charles Campbell did not see the horse-pulled cart that was making its way down the hill, too heavily laden for the driver to stop, and the naval officer was crushed beneath its wheels. Many in the crowd knew the story of the couple's long separation, and men and women both reached out to raise the woman to her feet, but she spurned their help and wept silently, her tears splashing onto his unresponsive lips.

After a long moment, she lay him down on the cobbles and rose to her feet. Speaking to no one, her face white and streaked with tears, her beautiful gown stained with blood and the filth of the street, she walked slowly back into the hotel and mounted the stairs to her room.

Once there, she began to pace once again. Serving maids, on their way upstairs to see to the stricken woman, heard the patter of her footsteps as they neared her room. As they got closer to her door, they realized that the

pace had grown faster and arrived in the room in time to see her throw herself from the window, falling to the street beneath to land only feet from Captain Campbell's lifeless form.

Both of the unfortunate lovers are said to haunt the inn, she pacing in her fourth-floor bedroom and he relaxing with a beer in the basement taproom where he'd known many companionable hours.

Captain Campbell's ghost has appeared to many folks since his death. Tradition has it that his apparition was seen within a year or two of his passing, and people recognized his ghost when it first showed up in the bar. He has most often been seen standing next to the window by the main fireplace in what is now the restaurant dining room; people walking past on Duke of Gloucester Street will glance into the window and spot a historically dressed naval gentleman enjoying a mug by a crackling fire. Annapolis is full of people in historical dress, so most assume him to be a reenactor or tour guide and just enjoy the imagery; others note with horror that he is unashamedly breaking Maryland law by smoking a pipe in a restaurant. They storm into the restaurant and berate the staff or head directly for the fireplace to complain to the man himself and are brought up short at the sight of the unlit fireplace and the empty corner. Servers and bartenders have spotted him at the end of particularly strenuous evenings, looking into the shadowy corner to see a cheerful man with side-whiskers and a friendly beard raising a pewter tankard with a wink and a nod as if to say, "Well done!"

His lady-love, waiting impatiently in her fourth-floor bedroom, does not have time to chat with guests or staff and is not known for cheerful interaction with the living: guests have been checking out of that room since 1817, some leaving without explanation but others recounting a variety of phenomena. Many flee the monotonous sound of footsteps pacing from door to window or the unpredictable window that opens and closes in defiance of lock or gravity. Some have a more direct experience of her presence, awakening in the dark hours of the night because they feel someone sit down on the edge of the bed, a chilly presence that settles beside them and taps an impatient foot on the floor. In the late 1980s, one guest came downstairs in a robe at 2:30 a.m. and demanded that management find her a room "with no dead people in it!" adding that she could take the sound of pacing feet, but she refused to share the bed.

With my lady in her upstairs chamber and the bridegroom firmly ensconced in the bar, it seems unlikely that the Maryland Inn's Romeo and Juliet will find a happy ending to their story, but love may end up conquering all.

Other rooms have less-frequently reported encounters. In August 2011, a ghost tour guide spoke personally with two guests who had checked into a

The hallways and stairwells of the Maryland Inn are the frequent site of unexplained occurrences and odd appearances—Civil War–era ghosts belt out ribald songs as they climb the stairs, sudden gusts of cold air rush past guests in the halls and many have been "passed on the staircase" by someone wearing a flowery perfume. *Rob van Schadewijk.*

third-floor room the night before. They had returned late from supper and a long walk through town and fallen immediately into bed and quickly into sleep. Around 2:00 a.m., the wife awoke because she heard a woman's voice in the room—a voice that was calling her husband's name. Groping for the light switch, she looked around the room and caught sight of a figure standing next to the bed. Through the streetlight filtering into the room she could see the glimmer of a long pale nightgown or robe, and she looked up into the face of a woman whose eyes seemed to burn with rage and whose posture was threatening. The guest let out a scream that woke her husband, who started from the bed and turned on the light. The intruder was gone, but a sense of cold discomfort remained in the room and the two slept little more that night. The next morning, they requested a room change.

Since 2009, there have been at least two encounters with a 1920s-era ghost on the fourth floor. Guests report hearing a woman's voice raised in argument and then the slam of a door; when they looked out into the hall, they saw a young woman walking away from them toward the staircase, in both cases describing her as wearing a short black dress adorned with beads, a feathery hair ornament and barefoot, her high-heeled shoes dangling from one hand. She walked angrily but unsteadily and disappeared into the stairwell. A moment later, there was a muffled shriek and the sound of a body tumbling down. The guests rushed to offer help, only to find the landings empty and the air filled with the rich fragrance of an unfamiliar perfume.

The cheerful and intoxicated figures of Civil War Union infantrymen have been spotted going up the stairs to the second floor, their voices raised in a song so lurid and pornographic that the words cannot be repeated here. Guests waiting for the elevator say they hear conversations going on behind doors that open to reveal an empty chamber. Others descend the beautiful curving staircases, feel the rush of a cool breeze moving up and past and catch the elusive scent of roses

There is no way to know how many historic guests remain in the building, but it is said that the Maryland Inn has more ghosts than any other in Annapolis, a testimonial to the reputation of the capital's most historic inn.

The Voyeur of the Governor Calvert House

The Governor Calvert House became one of the Historic Inns in the 1980s. It is the former home of Charles Calvert, the second provincial governor of

Maryland from 1720 to 1727. The building was originally a one-story brick dwelling with an extensive basement that contained a hypocaust, a forced-air heating system that dates from ancient Roman times, which not only warmed the floors of the house but also heated an orangery at the back of the property where the Calverts could cultivate warm-climate plants. Over the years, the building has been added to four times, enlarging it to its current size; an expansion in 1989 resulted in the collection of numerous historical artifacts from the grounds, and a glass-floored parlor on the ground floor looks into the lineaments of the old heating system.

Over the centuries, the building has been a residence, an apartment building and a hotel, and it is said to be full of ghosts that run the gamut from a gentleman in the dress of the early eighteenth century to a young woman who committed suicide in the 1940s. When the building was being worked on in the late 1980s, it was closed to guests for a time, and a paranormal investigative group got permission to explore the building. Using a variety of instruments, the group moved methodically through the building, measuring electromagnetic activity and other phenomena. Finally, they entered a room and turned on their equipment, and the resulting readings were so strong they almost fried their equipment.

Nowhere else in the building had they gotten such exciting results, and they persuaded a well-known medium to come to the building and help them research the ghost they were sure they'd discovered. When the woman entered the room, she said she could sense a strong male presence but that he was not interested in communicating with her. It took her three days to get answers from the spirit, who turned out to be named Domenic.

Domenic had been some kind of employee in the building in the late nineteenth century, and he'd died at work. No matter how she tried, the medium couldn't discover how he'd died, but she did discover why he was haunting the set of rooms on the second floor. Domenic was perfectly happy to be haunting a hotel because it gave him the perfect opportunity to enjoy his favorite activity—watching women take off their clothing.

No one knows what rooms Domenic likes to haunt because the medium evidently had to promise not to reveal his location before he would communicate with her—perhaps he feared that his presence might inhibit the guests that he so loves to spend the night with. But until the investigation revealed his presence, no one had the slightest idea he was there, so apparently he looks, but never touches, which may be a slight comfort for those who stay within the Calvert House's walls.

CHAPTER 7

St. John's College

HAUNTED HALLS AND FOREIGN SOLDIERS

The tree-canopied lawns of St. John's are the largest green space in the historic district, and the campus contains numerous historic buildings, some originally constructed there and others relocated to the property in the twentieth century when they were threatened with demolition elsewhere in Annapolis. The liberal arts college is a direct descendant of King William's School, a private college established in 1696, making it the third-oldest college in the United States. The college was an all-male military academy until 1937. St. John's College is a private coeducational liberal arts college known for its "Great Books" program, where students learn directly from the great thinkers of the past and are encouraged to discuss and analyze everything from musical works to non-Euclidean geometry to Kierkegaard.

The property has been the site of numerous historic events, from the Sons of Liberty meeting at midnight beneath the boughs of a tulip poplar that stood for four hundred years until disease brought it down in 1999, to an encampment by the troops of Lafayette in 1781, to its use as a field hospital and Union prisoner-of-war camp during the American Civil War.

BLADEN'S FOLLY

What is now called McDowell Hall was originally intended to house Maryland's Royal Governor Thomas Bladen, and in 1742, work began on

Once derided as "Bladen's Folly," the exterior of what became McDowell Hall stood as an empty shell until it was granted to St. John's College. For years the only building on the campus, it was used as a hospital during the Civil War. Devastating fires destroyed most of the original interiors in the early twentieth century, but it was rebuilt along the same architectural lines. *Author photo.*

an impressive Georgian brick mansion that was to crown the highest point of the lot. But factionalism in the legislature disrupted the funding, and the shell of the building, lacking a roof and windows, was abandoned and became known as "Bladen's Folly." It languished until 1784, when the unfinished building and the property were granted by the legislature to become the new site of King William's School. The college finished construction on the building, and classes have been held within since 1789. Until 1835, McDowell Hall (named in honor of the college's first president) was the only building on the campus and functioned as a combination dormitory, library, dining hall and classroom space. During the American Civil War, the campus was taken over by the Union army as a camp for paroled prisoners and the United States Medical Corps used McDowell Hall as its headquarters and field hospital.

During the twentieth century, McDowell suffered two catastrophic fires: the 1909 fire destroyed much of the upper portion of the building, while the

1952 conflagration caused serious damage to the basement and first floor. In both cases, the exterior was largely preserved and the interior was rebuilt to conform to the original floor plans, with minor modernizations.

The building is home to several unexplained phenomena, the most frequent of which is a strong smell of burning wood and odd encounters with closed doors whose knobs and wood panels are hot to the touch. Footsteps climb stairs to upper floors, voices are heard whispering in corners and canvas tents are occasionally sighted to the side of the building. These tents show the dim outlines of Civil War surgeons bent over tables at their bloody work with a pile of amputated limbs in a horrifying tangle outside the entrance.

THE CARROLL-BARRISTER HOUSE

The Carroll-Barrister House, built on the corner of Main and Conduit Streets in 1727 by Dr. Charles Carroll, chirurgeon (surgeon), is named after his son and is one of the oldest surviving residences in Annapolis. Dr.

Relocated to the campus, the home of Charles Carroll, barrister, now houses the admission and alumni offices for the college. The beautiful staircase that rises to the top floor often creaks beneath heavy footsteps—perhaps those of Carroll's longtime housekeeper. *Author photo.*

Carroll's son was Charles Carroll of Carrollton, a barrister who was the principal author of "The Declaration of the Delegates in Maryland," in which Maryland declared itself independent on July 6, 1776 (before the Declaration of Independence had been ratified by the conventions of all the colonies). The younger Carroll was the only Roman Catholic to sign the Declaration of Independence and was a fervent advocate of the patriot cause in Annapolis, much respected by the citizens.[9]

The building was moved to the St. John's campus when it was in danger of being torn down in 1955 and was meticulously restored. The house is in the shape of a T and rises to three stories, which are reached by a beautiful quarter-turn staircase with worn wooden steps. Carroll-Barrister now houses the college's admissions and alumni offices.

Many who work in the building are familiar with the sound of soft but firm footsteps ascending or descending the staircase; the ghost is said to be that of the Carroll's housekeeper, moving about her daily duties from kitchen to attic. Security guards who check the premises at night have heard a muffled female voice in the area that used to contain the pantry and have found lights and other electrical appliances turned on or off unexpectedly, and several reported being on the staircase only to feel a cold breeze rush past them. Perhaps there's someone at the door or something in the kitchen that needs her attention.

THE FRENCH MONUMENT

Erected in 1911, the monument is the site of an annual ceremony attended by the French Ambassador to the United States and is the first ever erected in memory of war's unknown soldiers. It rests at the western edge of the campus, on a small rise above the waters of College Creek, looking down on a small meadow that in September 1781 held an encampment of three thousand soldiers under the command of the Marquis de Lafayette, who made an immense social splash in the colonial capital.[10]

Dressed in their vivid uniforms, the French soldiers and their officers were the objects of much curiosity and goodwill from the citizens of Annapolis, and when the soldiers became ill with the fevers and infections so common in a hot colonial summer, they were nursed not only by their physicians but also by sympathetic women from town. Some recovered, but others did not, though the exact number is not known. "Old—very

old—Annapolitans can recall their great-great grandfathers speaking of a few simple headstones that marked the graves of some of the French dead buried here," the *Annapolis Capital-Gazette* noted in 1911, when President Taft dedicated the monument.

The stairs leading up to McDowell's bell tower creak beneath the feet of invisible visitors, classroom lights turn on and off and the smell of smoke and sound of panicked cries have been reported by security staff and students. *Rob van Schadewijk.*

The gravestones vanished long ago, but tradition holds that the soldiers were buried at the side of the lower meadow just beneath the monument. When College Creek floods and swamps the meadow, artifacts from the French encampment have floated to the surface or been exposed by receding waters: rotting leather cartridge boxes, rusty bayonets, belt buckles and coins. There have been reported discoveries of human remains, but those accounts date from the late nineteenth century and cannot be substantiated; it is possible that all of the graves remain relatively intact.

Visitors to the monument report a variety of phenomena, from inexplicable cold spots to the sound of voices shouting in a foreign language. The area directly behind the tall marble marker is said to be particularly active. Several self-proclaimed psychics claim to have been standing there when they felt a terrible wrenching sensation and looked up to see the landscape changed (they noticed the absence of a bridge and water tower that are on the modern horizon); after a long moment, they said they were "wrenched" back, to stand cold and shaken, looking once again at the landscape of the current day.

Standing above a lower field, the French Monument stands in memorial to the unmarked bodies in the earth below. No one knows how many soldiers lie at their final rest beneath the ground, but artifacts of the French encampment at the site appear after floods or storms. *Author photo.*

Several military reenactments have taken place on the campus grounds. In 1988, the meadow was the site of an overnight event that saw a couple hundred reenactors camped along the waters of the creek. In keeping with their mission of historical accuracy, the camp's commanders assigned sentry duty and had soldiers walking the perimeter of the camp during the entire night (their main priority was keeping college students away from the beer and the gunpowder). One sentry returned from his shift and settled down with his fellows by the fire at his camp. Where, he wanted to know, were the men who were reenacting as French troops? He hadn't seen any of the tents or uniforms in the camp that would have signaled their presence, but he'd exchanged salutes with a young man in a white uniform with vivid crimson trim—a uniform he recognized as French. Another man around the fire looked surprised and said that he, too, had encountered a French soldier, but that the uniform he'd been wearing had been sky-blue—a cavalry uniform. He'd looked around for the horses such a reenactor would normally be camped with but hadn't seen any and concluded they were stabled elsewhere for the night. The next morning, both went around the camp asking questions about the French reenactors they'd seen, only to be told that no such troops were present.

No troops in the camp wore uniforms that matched those seen by the sentries that night, but the descriptions do match uniforms worn by soldiers of the Forty-first Soissonai and by the cavalry that accompanied Lafayette in his visit to Annapolis.

Perhaps the sight of the encampment, filled with soldiers dressed in familiar uniforms, roused in those long-dead soldiers a desire to join once again in the brotherhood of arms and sent them forth to walk among them.

CHAPTER 8

SHIPLAP HOUSE

A TRIO OF DEMANDING WOMEN: ADRIANNE, AUDREY AND THE NURSEMAID

Pinkney Street, which rises from the square around the Market House and parallels Prince George Street (to which it is connected by an alley) is so narrow that it can be mistaken for an alley. Tidy clapboard-fronted row homes line much of the street, most of them dating to the late nineteenth century, but others go much farther back in Annapolis history.

Shiplap House, a brick and wooden edifice at the base of the street, is one of the oldest buildings extant in Annapolis, having been built around 1715. Edward Smith, who was the first occupant, applied for a license to keep a tavern in his home in 1715, and his widow, Mary, operated it until at least 1724. Later, John Humphrey was the landlord of a tavern at that address called the Harp and Crown; it was under his ownership in the late 1780s that the first ghost became a resident in the house.

Adrianne is said to have been one of the young ladies who "worked" at the Harp and Crown, serving in the taproom and most likely earning extra money as a prostitute. Popular legend says that she was a pretty girl who received a number of marriage proposals from the fishermen and sailors who frequented the tavern, but none of them measured up to her ideal, and she gently turned down every offer.

There are conflicting accounts of how the poor girl died; most have her meeting her end at the hands of a disgruntled suitor who could not stand the thought of her with other men, but she worked in a dangerous part of town and her profession was far from risk-free. However she died, her restless

The artist Francis Blackwell Meyer with his wife, Nell, in the front garden of their home. The house was designed to face Prince George's Street, but modern homes now fill the front garden lot and the building's front entrance was moved to Pinckney Street. Mr. Meyer had an intimate encounter in Shiplap House that made him so uncomfortable with the thought of living there that they shortly removed to another house in Annapolis. *Courtesy of the Historic Annapolis Foundation.*

spirit is said to have been wandering the halls and grounds of the building ever since.

Several people have described sighting a young woman in eighteenth-century dress moving about the garden adjacent to the building, while others have seen the same figure entering or leaving the back door of house. Encounters in the house have been numerous, with one of the most interesting documented in the journals of Maryland artist Francis Blackwell Mayer, who owned the house in the late nineteenth century.

Mayer, who spent much of the mid-century studying and painting in France, returned to Maryland in 1870, and by 1877, he was living in Shiplap House. Over the years of his inhabitancy, the artist glimpsed the figure of a young woman moving about the interior of the house, as well as in the gardens, where the neighbors saw her, too. It seems that Adrianne enjoyed having Mayer all to herself, because it was not until she perceived a rival that she took action.

In 1883, Mayer brought the twenty-seven-year-old Ellen Benton Brewer to the home as his bride and, within a few months, had an encounter with Adrianne that caused the newlyweds to move to a new home in town.

Mayer wrote that he'd gone up to bed in advance of his wife, who remained downstairs to finish some household tasks. He settled into bed and composed himself to sleep, but just as he was becoming drowsy, he heard footsteps on the stairs; thinking it was his wife, he turned his head to watch her enter the room. The artist thought it odd that she did not carry a lamp but waited as she closed the door and moved about the room in the dark. He noticed that the scent of an unfamiliar perfume filled the room—roses, he thought, and thinking his wife might have something romantic on her mind, he complimented her on the fragrance. She returned no response to his comment and said nothing as she pulled down the covers on the other side of the bed and lay down beside him.

In the darkness, the fragrance of the perfume came more strongly to him, and he moved closer to the silent figure, wondering why his Ellen did not speak to him. Perhaps she was angry or upset, he thought, and cuddled closer, his bare feet touching hers beneath the blankets. "Honey, your feet are freezing!" he exclaimed, recoiling in shock. When she still did not speak to him, he lost his temper and practically shouted at her, "Are you going to lie there or are you going to answer me?"

From the floor below, he heard his wife's distant voice calling up to ask what was the matter, while beside him in the bed, the figure shifted restlessly and let out a mournful sigh. With a cry that brought his wife running upstairs with a lamp, Mayer struggled out of the bedclothes and out of the room into the hallway. He took the lamp from his anxious wife and went cautiously back into the bedroom; although the fragrance of roses was still so strong upon the air that Ellen noticed it, the chamber was empty. But upon the bed, the shaken artist could see the outline of a figure that had lain next to his on the mattress, with the pillow above clearly indented by the pressure of someone's head.

One couple in the house had numerous encounters with the flirtatious ghost. The husband would wake because he felt "frisky hands" on his back and neck, only to discover his wife was sound asleep and facing the other direction. On one occasion, the wife was changing the bed linens and returned to the bedroom to discover the name "Adrianne" written on the mattress cover in red lipstick.

Visitors who take pictures of the beautifully restored house are often puzzled to find the face of a young woman looking out of a second-story

The grounds at Shiplap House are frequently occupied by the figure of a young woman in a light-colored dress who appears to be gardening or picking flowers; she's even been known to flirt with passersby. *Rob van Schadewijk.*

window—a face they certainly hadn't seen when they took the photo. Neighbors and employees of businesses in the immediate area have spotted the figure of a woman moving about the side yard. A dishwasher at an Italian restaurant said that one night he was out washing floor mats and heard a laugh. He looked across the street and saw a girl smiling at him from behind the fence of the front yard. He waved over to her, and

a waiter standing next to him having a cigarette asked him who he was waving at. When the dishwasher pointed across the street, he was shocked to realize the yard was empty.

The building currently houses offices of the Historic Annapolis Foundation, and those who work inside are quite familiar with the mischievous spirit. One woman was working alone in a second-floor office one evening, writing up a grant application, when she heard footsteps on the stairs. She'd been careful to lock up the building, so she was convinced that one of her coworkers had come back for a forgotten item or some other reason; she called out a greeting and was surprised to hear the steps stop at the middle of the staircase. She called out again, but no one replied. Grabbing a heavy paperweight, she walked out onto the landing and looked cautiously down the stairs: there was no one there.

She scolded herself for being so jumpy, went back to her desk and turned her attention once again to the application. A few moments later, she heard the footsteps again. This time, they came all the way up the stairs and seemed to enter the office next to hers. Truly frightened now, she reached for the phone and prepared to dial 911 to report an intruder. There was no dial tone: when she looked at the phone, she saw that the lights for all the extensions were blinking on and off, as if pressed by a mischievous child. Nerving herself, the woman left the room and went into the office next door; she was immediately struck by how cold it was in the room, and when she glanced at the desk, she saw that an unseen finger was pressing the phone buttons. When she let out a gasp, the lighted buttons on the phone went out and she heard the quick, light sound of footsteps moving toward her across the creaky floor. She stood, frozen with fear, and later recalled that she felt an icy hand push her aside so the invisible intruder could make its way back into the hall and down the stairs. She was unable to move for a few moments and listened as the footsteps moved away and fell silent. Grabbing her things from her office, she left the grant application unfinished and never worked alone in the building again.

There are two other ghosts who are reported to haunt Shiplap House: Audrey and her nursemaid. The two are said to have perished in some epidemic in the late nineteenth or early twentieth century, and many who spent the early years of their lives in the house have stories to tell of encounters with one or both of these two spirits.

Audrey is said to be four or five years old, with long golden hair arranged in ringlets and a blue dress. Children would tell their parents that "Audrey" had borrowed a toy, or broken something, or taught them a new game, and

most parents believed her to be an imaginary playmate or scapegoat. One man recalled that she had taught him to play marbles, a skill that astonished his father. There are no reports of adults seeing Audrey, but several former occupants claimed to have been startled at the sound of childish giggles at some mishap they thought they'd suffered in privacy.

Children and adults alike have reported encounters with Audrey's nursemaid, whom most describe as a very young woman, possibly in her early teenage years. She wears a long dark dress and an apron, and most stories describe her as haunting one bedroom in particular, the former nursery chamber. She evidently feels that her services are still needed: children living in the house have awakened to find a missing toy tucked into bed with them or have been startled by a gentle swat on the butt when they were misbehaving. One encounter passed into family lore, as described in the following passage:

> *They say it was when I was only 3 months old, and we went to the Shiplap house to visit my grandmother and her husband. They had bought the house from the historical society of Annapolis and did a little renovating. They took the 3rd floor, which had not been used for anything other than storage, and turned it into their master bedroom. This would be the spot of my experience. During our visit, my family claims they set me in my crib for my daily nap up on the third floor, then returned to the first floor living room where they all sat and talked. The say when it was time to wake me, they entered the room to find me in my diaper, still asleep, with the clothes I had been wearing folded nicely on the floor next to the crib. They had been aware of the spirit in the house. As the story goes, they put me down for a nap on a separate day and again returned to the first floor. This time, they came up before my nap was over to find me half dressed in the crib screaming bloody murder. My clothes this time were wadded on the floor. Though I can't say for sure that it actually happened, because I was 3 months, my family swears by it and will most likely take it to their grave. My grandmother always told us stories of that house, and their experiences in it.* [11]

The serene face of the oldest house on Pinkney Street belies the presence of the restless spirits within, and in the garden at twilight, Adrianne still wanders among the flowers, perhaps dreaming of love.

CHAPTER 9

THE HEADLESS GHOST OF CORNHILL STREET

Many of the homes on Cornhill Street have foundations that date to the establishment of Annapolis; the street connects East Street with the downtown harbor and its historic fish markets. The neighborhood in the colonial era was home to many watermen, and one of the homes was rented by a family of four, in which the two sons were about five years apart in age. The father was said to be a fisherman, and his two boys worked at his side.

During the heat of summer in the 1770s, fevers cooked their way through the population of many American cities. Bad water, terrible sanitation and swarming mosquitoes were only a few of the ways one could fall ill, and many died. Smallpox made periodic incursions, killing many and disfiguring the survivors. One of those infections paid a call to Cornhill Street. While all four family members fell sick, the parents died and the boys were left alone with no other family in the area.

The elder brother was just old enough to stand as guardian for the younger, and the two continued to live in the house, but without their parents' presence, the orphan boys went over to the dark side of behavior. They squandered their inheritance on rum and beer in the taverns and brothels of Hell Point, and when the money ran out, they made more in ways the neighbors quietly speculated about. The house was the site of numerous drunken gatherings, and the parties so disturbed the neighbors that they began to complain to the landlord of the property, but before he could take action, the problems abruptly ceased and the neighbors proudly took credit.

They had endured yet another night of shouting, a night that ended in the sounds of crashing furniture and cursing as the two brothers engaged in a drunken scuffle. Quiet fell in the early hours of the morning, and the next afternoon, a delegation of neighbors rapped at the door of the house until the younger brother, bleary-eyed and clearly hung over, opened it.

The delegation made its displeasure known, sternly informing the boy that there were to be no more parties and no more disturbances in the night: their patience was exhausted, and if the brothers did not immediately change their behavior, they would be taken to court. The boy apologized and promised to reform, but the neighbors demanded to speak to the elder brother.

The argument the neighbors had heard had so upset his elder brother that he'd ridden off to Baltimore, the young man explained. And after the neighbors went home, the house stayed quiet. The younger brother came and went, but there were no parties or drunken arguments, and fights no longer punctuated the night hours. In the absence of his guardian, the boy seemed to be making good on his promises of changed behavior.

The new serenity of the block was marred by only one thing: an unpleasant odor that grew into a disgusting stench over the course of a few weeks. The smell was traced to the brothers' house, and in the dirt-floored basement, the neighbors discovered a shallow grave containing a body they were convinced was that of the older brother—but without a head, identification could not be definitely made. After questioning, the younger brother confessed that his brother had died accidentally—the result of a fall as they had wrestled drunkenly together. But instead of taking responsibility for the accident when it happened, the young man succumbed to panic and decided to get rid of the body, which led to the next decision: Where to put it?

The obvious solution was to take it out of town on a boat and weigh it down, letting the body sink into the depths of the Chesapeake Bay. Even the closer fisherman's harbor would do, as it swarmed with crabs that would quickly devour the corpse, and even if the body was found, who was to say that the elder brother hadn't met with a mischief while he was roistering in Hell Point? But the younger brother wasn't able to figure out a way to get the body into the water without attracting notice; no matter what direction he went, he was going to pass through some heavily trafficked areas where someone was bound to see him.

After much thought, he hit upon a solution: he would use an axe and cut his brother's body into manageable pieces. He began by severing the head from the corpse and wrapping it in a cloth, hiding it beneath his coat and

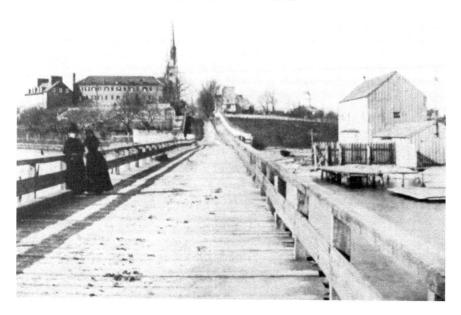

The view across the Eastport Bridge toward Annapolis looks up Duke of Gloucester and Compromise Streets; the first leading past St. Mary's Roman Catholic church and school to Church Circle, the second along the waterfront to the docks and markets at the bottom of Main Street. Thomas Chaney fled across the wide boards, his feet thudding against the wood as he tried to outrun a mysterious gliding figure whose broad shoulders had no head between them. *Courtesy of the Historic Annapolis Foundation.*

making his way through the dark streets toward the water. With glances to every side to make sure he was unobserved, he made his way onto the wooden bridge that had been built in 1870 to connect Annapolis with the Eastport peninsula. He leaned against the railing and let the grisly package fall into the water below.

No one seemed to have noticed anything, and there were few people about as he made his way back home. Once there, he was overtaken by disgust and revulsion at the idea of completing the job of disposing of the body—no doubt he was fairly drunk—and he sat down to compose himself. He fell asleep, waking in the early afternoon to find the neighbors angrily pounding on the front door. After they'd departed, he convinced himself that it was too dangerous to try to transport the rest of the corpse because they were surely watching him. He managed to dig a shallow grave in the basement and did his best to conceal the stench of decomposition, but the humidity of Annapolis defeated his efforts, the body was discovered and the neighbors were horrified.

The younger brother was found guilty of manslaughter and sentenced to jail, where he later died. The house was cleaned up and a new family settled

in. They experienced no issues at all, until the evening of the day that the guilty brother died in prison.

Legend has it that the family in the home was awakened that night by the sounds of heavy footsteps coming up the basement steps and into the hall, where they turned toward the front door. Rushing to confront the intruder, the man of the house discovered no one in the hallway and no sign of anyone near the front door, but the door to the basement stood open and the front door was ajar. He pulled the door open and looked out into the night, but saw no one on the street.

No one is sure which of the houses on Cornhill Street now stands above the basement in which the body was buried, but the ghost appears to spend most of its time on the streets because he's got a mission. When you have a headless corpse, tradition holds that the unquiet spirit will go forth to search for its missing appendage—and his skull is somewhere in the Annapolis Harbor.

Elihu Riley, in his book *The Ancient City*, includes a few accounts of ghost stories; one of those involves a headless spirit on the waterfront road that led to the Spa Creek bridge. The gentleman who encountered him in the late nineteenth century was Mr. Thomas Chaney of Eastport, who recounted the events of one memorable evening to Mr. Riley. After helping his father sort and pack fish at the seafood market, the older Chaney sent his seventeen-year-old son home to bed. As the young man approached the foot of the bridge, he felt compelled to look over his shoulder; standing beneath a street lamp was a dark and bulky figure. As if it sensed the younger Chaney's gaze, the figure began to move toward him and, thinking that it might be his father, he waited before crossing. But as it drew closer, he was filled with a sudden sense of horror because he could see that the tall shape was not his father and that it was not only moving with a strange gliding gait but there was no head on the broad shoulders. He said, "The moon was shining bright, and I could see the object quite clearly as I occasionally turned around to look at him, for he followed me at the same distance that he had maintained when I first realized that he had no head. One thing struck me as strange. The planks of the bridge at that time were very loose, and I noticed that while they rattled as I went, the man on my trail moved with a noiseless step."

Chaney, looking over his shoulder and realizing that the figure was gaining on him, bolted for his home on Chesapeake Avenue. Just as he reached the doorstep and was fumbling with the door, he felt a hand upon his shoulder and smelled a terrible foul odor. When his mother opened the door, he

The docks and markets of Annapolis in the early twentieth century were far quieter than those of the Colonial period, when the city was an official port of entry for Maryland. The ferry across the Chesapeake that took Thomas Jefferson to Rock Hall departed from Annapolis, owned by Samuel Middleton whose tavern building stands at the far right of the picture, presently the site of a new Middleton Tavern. *Courtesy of the Historic Annapolis Foundation.*

knocked her down to slam it shut behind him. Ignoring her frantic questions, he found his father's gun and threw open the door to find the street silent and empty.

Mr. Chaney's story dates to the 1880s, but others have had more recent encounters. A respected local fisherman and World War II veteran was preparing to head out onto the water in the dim light before dawn when he saw a figure wandering aimlessly about the docks. Concerned that the individual might be drunk and fall into the water, the fisherman kept an eye on him and, as the figure drew closer, became so worried for his safety that he left the boat and walked toward it. He noticed two things: that the figure was shorter than a normal man and that the individual was obviously intoxicated, as he stumbled and lurched around the dock. Suddenly, the fisherman realized that there was no head on the shoulders of the body, and letting out a scream, he turned and ran to his boat. Once onboard, he hastily cast off the lines and left the dock and the menacing figure standing upon it, looking back once or twice to prove to himself he had not been imagining it.

During the course of his day, he pondered what he had seen and, even though he knew he'd be ridiculed, felt compelled to share the frightening story when he stopped at his favorite bar for a drink on the way home. He came in for a good amount of teasing at first, but then a local politician

silenced the laughter by repeating a story his own son had told him about an odd encounter he'd had just half a year before.

The young man was making his way home from a midnight basketball activity at the Recreation Center on Compromise Street. As he turned onto Green Street and began to make his way up the hill, he noticed an unsteady figure in the courtyard of the elementary school. Annapolis is no stranger to drunken people wandering lost on its dark streets, and the bars of Main Street were just a few hundred feet away; the young man figured that the man was intoxicated. As the figure stumbled down the stairs and onto the sidewalk, the boy crossed to the other side but kept an eye on him as he stumbled out into the street between the parked cars. A moment later, when the boy drew closer, he realized to his horror that the stumbling figure had no head.

Letting out a shriek of terror, the teenager bolted back down Green Street, looking over his shoulder to see that the figure was no longer stumbling but was pursuing him with the same gliding gait that Thomas Chaney described in his encounter—and also to note that it was gaining on him! He ran faster than he had ever run before and suddenly found himself in the middle of Main Street; seeing people on the sidewalk, he slowed and turned, no longer afraid to accost his pursuer. The streetlights cast a wide swathe of light up Green Street, but there was no one to be seen.

Some think the ghost is seeking assistance with the problem of locating his head. They say he chooses a living helper and then drags him into the murky waters of Spa Creek to sink to the bottom where those old bones lie, and while ghosts don't need to breathe, all humans do…

It's a good idea to be careful on the streets of any city, late at night. But if you must go walking near the Annapolis waterfront after midnight, it would be wise to wear your running shoes.

CHAPTER 10

HELL POINT

PIRATES, GHOSTLY VESSELS AND THE NAVAL ACADEMY

The site currently occupied by the United States Naval Academy was once better known as "Hell Point," an untidy area that catered to the vessels that anchored off Annapolis. Two military emplacements on opposite sides of Spa Creek guarded the entrance to the downtown waterfront, but the taverns, inns, brothels, shady merchants who dealt in questionable goods and a host of other businesses crowded the point of land that extended out into the Severn River, from which you could clearly see the broader blue of the Chesapeake Bay beyond. The harbor at the base of Main Street was filled with local traffic— fishermen, local merchants and the like. Hell Point extended out toward the Severn River, where the tall ships lay at rest in the sheltered anchorage of the river, re-provisioning, unloading merchandise, taking on cargoes of tobacco and other produce. Many of the ships were merchant traders following a "triangular" trading route[12] across the Atlantic or down to the Caribbean island colonies, but others sailed under national flags that came down once they'd left port and were safely out to sea, to be replaced with the Jolly Roger.[13]

THE PIRATES OF HELL POINT

Piracy was rampant on the Chesapeake until after the American Civil War, although the ancient and honorable art of smuggling continued into

the modern era and may well go on today. The huge estuary is the site of a thousand sheltered coves and isolated islands that offered a multiplicity of hiding places for the ships of marauders. Edward Teach, more commonly known as Blackbeard, was said to lay up his ship for repairs along Maryland's Eastern Shore, and the infamous Captain Kidd is supposed to have concealed his cache of treasure somewhere on Gibson Island, to the north of Annapolis.

The pirate ships that prowled the Chesapeake Bay were crewed by runaway slaves, indentured servants, merchant sailors or British sailors on the run from the Royal Navy and others who found life on land too challenging and the lure of illicit profit too enticing. These vessels struck at merchant shipping and staged raids on isolated settlements, taking not only goods but also women and new recruits to life beneath the black flag (some of the women became pirates themselves!). Few pirates lived a long life onboard ship. Disease, malnutrition and accidents—not to mention mortal wounds sustained in combat—took a terrible toll on the crew during every voyage. Some recruits were forced into the life while others came to it willingly, but the punishment for a captured pirate was the same, regardless of one's personal history: death.

In the early years of Annapolis's history, condemned pirates were placed in iron cages that were then hung from gibbets placed near the entrance of the harbor, where they slowly died from exposure or dehydration. The bodies were left in their iron coffins as they rotted and turned to bones, which would sift out of the bottom to lie in an untidy pile beneath the dangling cages. It was customary to place a sign or notice near the gibbets so that sailors entering or leaving the harbor were reminded of the penalty they'd pay should they choose a pirate's life.

The historical site of these gibbets was somewhere on the tip of Hell Point on or near the grounds of Fort Severn, where the peninsula extends into Spa Creek.[14] For centuries, sailors cruising past what is now the seawall of the Naval Academy have reported seeing dangling cages that glow with an eerie blue-white light, and some have seen skeletal figures within, bony arms reaching past the bars to gesticulate and beckon to the passing ship. Local lore holds that such a sighting is a portent of dangerous storms to come: ships coming into the harbor should tie up securely, and those leaving should reconsider. One ship that perhaps ignored such a warning, a merchant vessel that was forced aground in a hurricane in 1774, has been spotted crossing the bay near Annapolis prior to severe weather, passing sailboats and other vessels in utter silence, its sails extended before the blow of a powerful wind and a lone figure standing at the wheel, navigating toward an unimaginable destination.

THE SPIRITED SAILORS OF THE UNITED STATES NAVAL ACADEMY

In 1842, midshipman Philip Spencer and two others were hanged at the yardarm of the small brig *Somers* for mutiny against their captain, an incident that shocked the nation—and one that led to the founding of the Academy. A "midshipman" is an officer in training, and until this point in American history, naval officers received their training on the job—training that varied widely from ship to ship. To ensure that all officers would be properly trained in naval procedures and essential knowledge, Secretary of the Navy George Bancroft opened the Naval College in Annapolis in 1845 on the site of Fort Severn with fifty midshipmen and seven professors; in 1850, the name was changed to the United States Naval Academy. With the exception of four years during the American Civil War when midshipmen were relocated to Newport, Rhode Island, to remove them from close proximity to the battlefields and the effects of blockades, the Academy has been an active and important part of life in Annapolis.

There are several ghosts on the Academy grounds that predate the establishment of the school and that are most likely sailors or travelers who met unfortunate ends at the taverns or in the dark and dangerous

The Naval Academy during the late nineteenth century boasted elaborate gardens along the Severn and wharves for training ships and ferryboats. The site of Fort Severn was at the tip of the spit of Hell Point; the Colonial fort was incorporated into the Academy and the punishment gibbets on which caged pirates were hung to die along the modern Academy seawall. *Courtesy of the Historic Annapolis Foundation.*

alleys of Hell Point. Professors, midshipmen and guards at the school have reported sightings of figures in colonial garb, male and female, near the area where the wooden buildings and earth walls of Fort Severn once stood. Their names and their motives are largely lost to history, but at least two of the spirits who linger have stories that have passed into Academy lore.

JOHN PAUL JONES

John Paul Jones was a Scotsman who became the Continental navy's most famous captain, known best for his defiant challenge to the British commander of the *Serapis*, a vessel locked in violent combat with Jones's own *Bon Homme Richard* off the coast of England in 1779—"I have not yet begun to fight!" Jones knew he could not defeat the British ship at a distance because of its superior firepower, so he drove his own right up against the *Serapis* and sent boarding parties across and used marine marksmen in the rigging to pick off the British sailors. At one point toward the end of the battle, the British commander noticed the American ship was no longer flying its colors (they had been shot away) and called across to see if Jones had intentionally struck them, signaling a surrender. One of the crew later said that Jones responded, "I may sink, but I'll be damned if I strike!"

Jones earned many commendations over his career with the Continental navy, but many of his crewmembers disliked serving with him, finding him a harsh master aboard ship. His fellow commanders frequently had difficulty working with him, and once the war was over, Jones could obtain only sporadic appointments from the United States government. Sent to Europe to negotiate prize money owed by various governments in 1783, he went on to serve under Empress Catherine II in Russia for several years, before returning to Paris in 1790. He was never to return to his adopted homeland and died in the French capital in 1792. Because of his service during the war (he had received several awards from the King of France), he was buried with honors in the Cemetery for Foreign Protestants in Paris in a lead-lined casket that was filled with alcohol to preserve the body, in case the United States should ever wish to retrieve and identify it. The cemetery fell into disuse, and it was not until 1905 that General Horace Porter, ambassador to France, located the burial plot after a six-year search and arranged for the body to be returned to the United States.[15]

A copy of the death mask of John Paul Jones, displayed in the crypt of the Naval Academy Chapel. Midshipmen are counseled to stand a vigil before the massive sarcophagus containing his remains, in the hope that the old hero will give them guidance on their course as naval officers. *Author photo.*

Escorted to the United States by a convoy of American warships and destroyers, Jones's coffin was installed at Bancroft Hall in 1906, following an elaborate ceremony at which Theodore Roosevelt gave a lengthy speech. In 1913, John Paul Jones was entombed in an elaborate marble and bronze sarcophagus in the Crypt of the Naval Academy Chapel, where he remains to this day.

A long-standing tradition at the Academy holds that the ghost of John Paul Jones will whisper to an attentive midshipman, advising them on how best to personify a naval officer or recommending a particular course in their career; for many years, it was a tradition for First Class midshipmen (seniors) to stand a vigil in the crypt to hear what the old hero will advise. The Marine Honor Guard that stands watch in the crypt have reported hearing a voice that "seemed to speak to me," and there are frequent sightings of a shadowy figure standing near the sarcophagus, unexplained malfunctions of electronic gear, lights turning on and off and other phenomena. Visitors to the crypt repeat similar stories and show numerous pictures blurred with orbs, obscured by spirals of strange mist, and several have claimed to capture the figure of a tall man in a cocked hat.

A restless spirit in life appears to have found no rest in death, but the ghost of John Paul Jones could have found no better place to settle than here, his spiritual alma mater.

A MARINE LIEUTENANT'S MYSTERIOUS DEATH

The other well-known ghost on the grounds is that of young marine officer Lieutenant James Sutton, who died at the Academy under questionable circumstances in 1907. After an evening with friends at the Carvell Hall Hotel (Brice House, 42 East Street), Sutton offered three brother officers a ride back to the marine camp in his taxi. They accepted, and the four men got into the car, which drove them onto the grounds of the Academy and was making its way toward where the marines were posted when one of the men told the driver, William Owens, to stop.

Owens later testified that after he stopped, "[Second Lieutenant R.E.] Adams jumped from the front seat and taking off his coat and hat, threw them on the ground. He made a rush for Sutton as he and the other officers got out of the car. The two officers grabbed Sutton by the arms, and I heard Sutton say: 'Go away, Adams. I don't want any trouble.'" The men pulled Sutton from the car and told the driver to 'get lost,' calling a sentry to escort him from the grounds. As Owen and the sentry made their way back to the gate, they heard a shot ring out.

The story as it was reported at the time said that "Second Lieutenant James N. Sutton, Jr., United States Marine Corps, is dead at the Naval Academy Marine Barracks, his death resulting from a 32-caliber bullet fired into the right side of the head." The officers who'd ridden back with Sutton claimed he'd gone berserk, pulled a gun and shot himself.

Because of the officers' testimony (which went largely unquestioned), the official report cited the cause of death as a mental breakdown and suicide, an explanation that did not sit well with his friends, who did not recognize the irrational individual described in the report. But it was Rosa Sutton, James's mother, who fought the official conclusion and ultimately forced a new autopsy and a new hearing into the matter. During a hearing in 1909, letters she had written after her son's death were read aloud in the courtroom; in one of them, she wrote of her experiences on the night her son died, thousands of miles away from their Oregon home:

The love between Jimmie and myself was the greatest that could exist between two persons. If Jimmie met with an accident, I felt it at once. Well, the night those beasts were laying their plans for Jimmie an awful fear came over me and my two daughters so we could not talk and each kept away from one another from fear of betraying our feelings. The next day Mr. Sutton came in and asked if I could stand some awful news. He told me that Jimmie was reported to have killed himself. Oh, God... if Jimmie had not spoken to me I would have died. Then Jimmie came to me and said "Mother, dear, don't you believe it, I never killed myself. Adams killed me, they beat me to death and then Adams shot me to hide the crime," He told me how they laid a trap for him and how he walked into it; how Utley grabbed him to pull him out of the automobile, how they held him and Ostermann beat him about his forehead being broken, his teeth knocked out and the lump under his jaw, and how, when he was lying on the ground, some one kicked him in the side and smashed his watch. He begged me not to die, but to live and clear his name. Well, after three weeks, I proved some things he told me were true, and after repeatedly demanding the evidence, after four months I got it, and within the last month I have proved everything he told me. Nothing could separate Jimmie from me, not even death, and Adams, Utley, Potts, and Ostermann will never know a moments rest on earth. Why should they?[216]

One of the pieces of evidence she cites above was the lieutenant's watch; when the family arrived in Annapolis and was given his personal belongings, his pocket watch was indeed smashed, as if by a mighty blow. Another was the re-autopsy, which showed that the young man had been brutally beaten before being shot. Unfortunately, while the official cause of death was changed from suicide to homicide, there was not enough evidence to charge anyone with the murder, nor was anyone able to discover a motive for the attack on Sutton. Once the verdict was changed, James Sutton's spirit never again spoke to his mother, but his ghost still roams the grounds of the Academy, perhaps in anger at the navy for its complicity in covering up his murder.

The ghost of Lieutenant James Sutton has been sighted by dozens of credible witnesses over the years, from physics professors to marine guards to midshipmen. Bancroft Hall, the massive dormitory of the Academy, is home to many of the sightings, with startled midshipmen awaking in a sudden cold draft to find his figure hovering over their beds. In recent years, security was

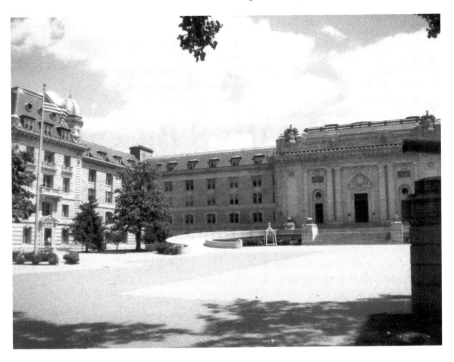

The Academy's Bancroft Hall is the largest dormitory in the United States, home to the entire brigade of midshipmen. Many students at the Academy have awakened to find the ghost of a young man floating above their beds or outside their window, reportedly the spirit of James N. Sutton, who was murdered on the grounds in 1907. *Author photo.*

increased after multiple reports of a figure that appeared to be walking along or "walking through" the brick wall that separates King George Street from the campus.

Guards and midshipmen out after dark have both reported seeing glowing lights moving about the grounds, and still others look out of their upper-story dorm room window to see a pale face watching them through the glass. In recent years, paranormal investigators researching this haunting have reported a host of phenomena, from bizarre electromagnetic field fluctuations to the sound of footsteps in the corridors of Bancroft Hall.[17]

Mrs. Sutton may have been right when she said, "[They] will never know a moments rest on earth," when talking about the murderers, but it is seems that her Jimmie hasn't found any, either.

CHAPTER 11

THE JAMES BRICE HOUSE

ANNAPOLIS'S MOST HAUNTED HOUSE

S et back from the street on a raised footing at the corner of East and Prince George Streets, Brice House is a five-part Georgian mansion on which no expense was spared when it was constructed in the late eighteenth century. From its large ballroom to the spacious bedchambers on the upper stories, the house is a testament to the wealth and taste of the family that owned it. The building is remarkable in that its eighteenth-century structural materials and embellishments have survived virtually intact, from the magnificent stairway of Santo Domingo mahogany to the original window frames and glass to the wood-pegged flooring. Brice House is famous as one of the most "impressive brick buildings of American Georgian Architecture."[18]

James Brice was born in Anne Arundel County in 1746, the son of John Brice Jr. and Sarah Frisby Brice. His father was a prominent landowner who began construction of the mansion in 1766, erecting the western wing and hyphen that were used as a town apartment and office until the rest of the building was completed in 1773. In 1781, James Brice married Juliana Jennings, and the couple took possession of the mansion, which became so associated with the son that John Brice's name was no longer used to refer to it.

The younger Brice was not only one of the largest landowners on the East Coast, but he was also a lawyer who held a number of positions in both colonial and post-Revolutionary Annapolis. As senior member of the Governor's Council in 1792, he became acting governor of Maryland for

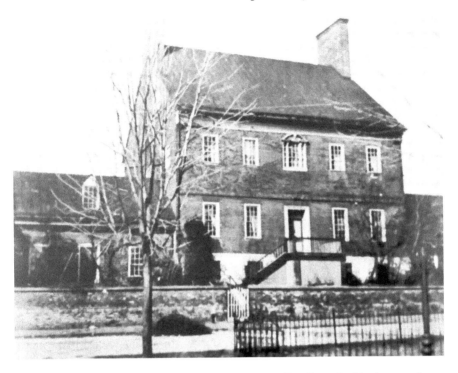

The massive five-part Georgian mansion rises high above East Street in this photograph from the late nineteenth century. The Brices were prominent citizens who were among the largest landowners on the Eastern seaboard, but they were stalked by violence and afflicted with mental illness. *Courtesy of the Historic Annapolis Foundation.*

several months after the death of George Plater, and he was twice mayor of Annapolis. The mansion on East Street was the site of numerous receptions and balls, with guests strolling from the beautifully appointed reception rooms into the spacious gardens.

The Brice family had everything: land, power, money and respect. In addition, they had both metaphorical skeletons in their closets and a real one that was discovered in a hidden basement stairwell.

Mental illness is said to have been a problem for several members of the family, from intense depression to more serious and violent behavior. In the light of modern science, we can speculate that perhaps some of those deemed "mad" were in fact suffering from other illnesses or congenital defects, but no one would have made such distinctions in the eighteenth and nineteenth centuries, and those who appeared mad were judged to be so. Mental illness was a serious stigma at the time, signifying some taint in the blood that might pass to future generations, and many perceived madness itself as almost

demonic in origin. A prominent family would do its best to keep such people out of sight—hence the stereotypical crazy aunt in the attic.

Several members of the Brice family spent their lives out of the public eye, and the third-story rooms in which they lived and died still echo with the sounds of their restricted lives: footsteps pacing in a ceaseless circle, the creak of a rocking chair, the dry flick of Bible pages and the occasional voice raised in song or in seeming complaint or anger—visitors to one attic chamber were often startled to hear an emphatic voice say, "I'm not mad!" But these unhappy ghosts pale in comparison to the restless or angry spirits who roam the lower floors of the house.

According to local legend, there are at least six ghosts in the mansion (including the unnamed spirits on the third floor), and there may be more. Colonel John Brice, the builder of the house, has been reported to be active within its walls, with everyone from family members to Naval Academy professors having encountered his ghost in the rooms and hallways. One

James Brice and his daughter, Juliana. Through a web of marriages, the Brices were related to most of the prominent families in Maryland. *Courtesy of the Historic Annapolis Foundation.*

St. John's College tutor who lived in the building in the mid-twentieth century was dumbfounded to see a gentleman in an elaborate plum-colored formal ensemble from the eighteenth century in the hall outside his apartment. At other times, the colonel has been observed looking from the second-story window of the western hyphen (the connecting building between the main house and the wing building) where his bedchamber was located.

His grandson Thomas Brice was a lifelong bachelor whose body was discovered in the library of the home one morning, clad in his nightshirt and cap and lying

in a pool of blood, the fireplace poker that had been the instrument of his death lying atop his lifeless form. The identity of the murderer was never proved, but it was widely believed that Thomas Brice was killed because the contents of his will were made known in some fashion, and each of his servants was to receive a monetary bequest upon his death. Local lore has it that Brice's valet was complicit in the murder, perhaps involving a confederate who then killed the valet—who was never seen again after the night of the murder. Whether the valet was a faithless servant or a hapless victim who was killed along with his master will never be known, but witnesses in the house have reported hearing a struggle in that room, and one claimed to have seen two men fighting near the fireplace.

The ghost of Thomas Brice has been seen in the library where he died and in his second-floor bedchamber; several photographs of the building have captured the image of a man looking out of the window on the upper story, a white nightcap atop a face that closely resembles Mr. Brice's description with its small round glasses and thick white mustache.

Another of the family's servants who is said to be hanging around the building and grounds is the longtime valet of Colonel James Brice III, who died in the late 1870s. His name lost to history, the poor man met his end after enjoying a couple of drinks at the tavern on the corner opposite Brice House; walking home in the late evening, the man was accosted, robbed and beaten nearly to death on the street. The injured servant managed to drag himself into the carriage house but died before he could attract help from his fellows. The Annapolis Police Department has received calls from people who witnessed a mugging at the intersection of East and Prince George Streets and described the victim as a reenactor or historic tour guide, both of which are common in Annapolis. Other people have had encounters with a badly beaten man who stumbles around the intersection, vanishing when they attempt to help or speak to him. One Naval Academy professor in the 1930s saw a thin, white-haired man, neatly dressed in an old-fashioned black suit, walking down the hall toward him; when the professor caught his eye, the man vanished. At other times, the same figure has been observed near the carriage house entrance or walking across the street (presumably in search of beer).

Without a doubt, the ghost known as the Crying Girl is the most famous within the walls of Brice House. Beginning in the late eighteenth century and continuing into the present day, neighbors and passersby have reported hearing screams and cries in the vicinity of the building—a woman's voice that begs for rescue only to break down in plaintive sobbing. As with the ghost

of the valet, the police in Annapolis are quite familiar with the panicked phone calls generated by those who hear these screams.

Local rumor at the time said the voice belonged to a female member of the family who began to go mad in her early teenage years. Hidden from public view, the girl was said to have gone to live with family in England, and her disappearance from Annapolis generated no suspicion. It is said that at some point, the girl's insanity become so uncontrollable and her behavior so violent that the family took steps to end her suffering as well as their own.

Workers making structural improvements to the building's basement in the 1890s were surprised to discover that the plaster of the underground hallway concealed a bricked-in doorway. There have always been rumors that say an unspecified treasure is hidden in the house, and there was great excitement about what lay behind the door. After removing the bricks, the workers forced the door open and gaped at the contents of the small room that lay beyond: the only thing within it was the partially mummified body of a young woman. To their further horror, when they happened to look at the interior side of the door there were deep gouges and scratches in the wood, and in some of them, the stubs of broken fingernails were clearly visible.

While some claim the family hid her body in this unused stairwell shaft after her death (in order to keep the secret of her illness), the fingernails in the door propose the chilling possibility that the girl was bricked into the room and left to die.

After the body was discovered, there was a great deal of speculation as to her identity, with many saying that she was most likely an inconveniently pregnant mistress or chambermaid that someone in the family wanted to get rid of. If that had been the case, the Brices—so wealthy and powerful—could have hired someone to take the girl for a sailing trip from which she would not have returned or sent her off to Philadelphia or some other city with a purse of money and instructions not to return to Annapolis. That the body was hidden in the house—and that a staircase was lost in the process—makes it likely that she was a member of the family.

Examination of the family genealogy has been inconclusive, and we will most likely never be able to identify the poor girl. The bones were interred in one of the Brice family's sepulchers, but even burial in consecrated ground has not stilled her voice: she can be heard in the house and on the street outside, begging for rescue.

One St. John's tutor who lived in the house in the 1930s went into a basement storage area and was overcome with a chill far colder than the

summer day could account for. As he dug through his boxes, anxious to escape the cold, he heard the sound of sobbing broken by a voice whispering hoarsely, "Please help me." Abandoning the search through his belongings, the professor went into the hall and made a quick search of the other rooms; finding no one, he went hastily back upstairs. Many have reported hearing someone weeping when they went into the basement, but most of those who report an encounter with the Crying Girl are on the streets outside—perhaps based on her experience, she feels that strangers will be more sympathetic to her than will the people living inside the house.

Local tradition holds that the ghost has been active since the early 1800s and possibly earlier, and she has certainly been heard in recent years. One of the authors had a personal encounter with the Crying Girl in 1984. A St. John's College student living at 16 East Street, she paid an evening visit to the campus before heading down Prince George's Street and home. As she rounded the corner onto East Street, she heard screams and looked frantically for the source of the cries. There was no one in sight, but the sounds seemed to have come from the hulking brick building on the left, a historic site that was covered in the scaffolding and chaos of restoration work. The windows had been removed from the sashes, leaving gaping openings to a dark interior. Thinking that perhaps a girl had been dragged into the building and was being assaulted, the author ran down the street to her house, grabbed the phone and called the police to report an assault in progress.

When she saw the police car appear, she felt safe to return to the corner and was startled to discover the officers leaning nonchalantly on the brick wall that framed the lot. She demanded to know why they were not entering the building to search for a possible victim and astonished at their response—they'd come because they had to, and if they heard anything they'd certainly go in, but there wouldn't be anything to find because there never was. The officers mentioned the rumor of the ghost associated with Brice House, but she wasn't convinced. One of them consented to take a look in the building after she insisted, entering through one of the windows off the scaffolding. She could see the darting light of his flashlight moving about the first floor of the building, and she strained to listen for further cries, but heard nothing. The officer emerged to report an empty house, and she took a last look up at the severe brick face of the building before walking back down the street to her rooms. It was a long time before she could bear to pass that haunted corner after darkness fell.

One of the paranormal investigative groups that frequent Annapolis is said to have conducted an experiment in the basement chamber before it was demolished in later reconstruction. To answer the question of why

no one heard and responded to her pleas at the time of her entombment, they hired an opera singer and had her stand in the stairwell while they temporarily walled her in, approximating the thickness of the wooden door and the bricks and mortar that had covered it. Signaled by headset, the woman took a deep breath and began singing at the top of her lungs, moving about the room to direct her voice in every possible direction. Sensors in the house, on the grounds and in the street picked up no audible trace of what could clearly be heard through the microphone she was wearing, and the conclusion was inescapable: the stairwell was an acoustic dead zone, and no sounds made within it could possibly be heard on the street.

In archaeological work done on the site in the late 1990s, a fascinating discovery was made in the east wing of the house: beneath the kitchen floor were artifacts dating back 130 years that had been placed to form a cosmogram—a West African symbol of the circle of life. The matches, bottles and buttons placed beneath the floorboards were used to attract, trap and petition spirits and were put there by free African Americans practicing hoodoo, a religion that fused West African spirits with the tenets and language of Christianity. Practitioners called spirits to beg for information or to ask for favors or intercessions, and placement of the cosmogram was supposed to limit the ability of evil spirits to enter, protecting those around it.[19]

> *The Brice House hoodoo cache was found in an oval pattern to the south side of the doorway and just to the north side of the same door. Caches were also adjacent to each fireplace in both the north and south rooms. The room had a north-south passage and an east-west dividing wall, thus creating a cross pattern, or x. The artifacts were placed at the focal point of the cross-the doorway itself.*
>
> *19- and 20th-century folklore accounts of Hoodoo practices, as well as lyrics found in numerous blues songs, make reference to the power of the crossroads. The Hoodoo artifacts make a crossroads that was intended to give its makers active control over their own lives-including such applications as curing rheumatism, protecting children, assisting with finding a mate, and warding off a harsh mistress or master.[20]*

While such caches have been found in other historic buildings in Annapolis, the size and location of the cosmogram at Brice House, which lays just above and to the side of the Crying Girl's barren rock cell, begs the question of whether those who placed it did so to control the bone-chilling cold of her presence and silence her plaintive cries.

CHAPTER 12

THE BROOKSBY—SHAW HOUSE

The distinctive gambrel roof with its widow's walk and wide covered porch is clearly visible from the grounds of the statehouse across the street. Built between the years of 1720 and 1725, the Georgian building is the oldest on State Circle and was the "dream house" built by butcher Cornelius Brooksby for his beloved wife, Mary, and their children.

Sadly, Cornelius was never to realize a life of domestic bliss within its walls; construction took far longer than expected, and he died one year before the house was completed.

Evidently, his widow did not inter her heart along with Cornelius, because several months after his death, Mary took a new husband, Thomas Gough. When the house on State Circle was finished at last, the newlyweds moved in.

From the first days of their residency, it was evident that they were not alone in their new home, and as the weeks went by, Mary came to suspect that the angry spirit of her husband was behind the sounds of pacing footsteps, breaking glass and other noises that kept the couple nervous and on edge. Her suspicions were confirmed when she and her husband awoke for the first time to find the misty figure of Cornelius hovering over the bed, his face twisted in an angry scowl.

The nocturnal visits to their bedchamber continued over the next few months, and the noises escalated into malicious pranks directed at Thomas Gough. He was poked and prodded from his sleep, knocked down staircases

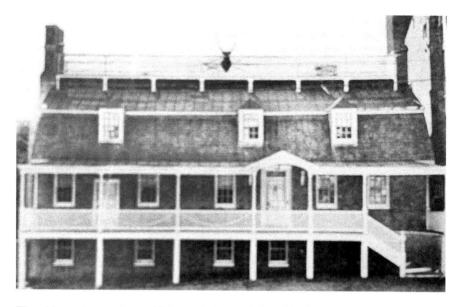

The wide porch was a later addition to the house designed by Cornelius Brooksby in the mid-eighteenth century. One of the oldest buildings on State Circle, the picture shows it during the period when the Annapolis Elks lodge was housed within it, in the early years of the twentieth century. *Courtesy of the Historic Annapolis Foundation.*

and pelted with glass and china ornaments. After months of torment, the Goughs abandoned the house.

Some time later, Cornelius and Mary's granddaughter Mary Brooksby-Long decided to move into the home with her new husband. From the first days of her occupancy, Mary complained to friends that she did not feel welcome in the house, and within weeks, the couple began to experience the same phenomena as the Goughs: unexplained thuds and footsteps, objects falling or moving, glimpses of a shadowy male figure and the frequent crash of shattering glass. Eventually, she and her husband fled the house, and it remained empty until purchased by renowned cabinetmaker John Shaw in 1784. The Shaw family remained in the house for 123 years and reports of footsteps, noises and other events continued through their residency, but the Shaws did not seem to have inspired the type of personal harassment Cornelius dealt to his one-time wife and to his granddaughter (who closely resembled Mary Brooksby).

In the early twentieth century, the building was sold to the Annapolis Elks, and it remained as the local lodge until 1960. The State of Maryland purchased it in 1961, and it now houses legislative offices. Throughout the years, reports of unusual activities have continued. Security officers

conducting patrols of the property have had several unsettling encounters with the ghost of Cornelius Brooksby, whose fondness for Christmas has led to a large number of incidents during the holiday season.

In one recent event, workers in the offices erected a large and beautiful tree glittering with clear glass ornaments, twinkling lights and crowned with a beautiful angel. Late one evening, as they prepared to enter the building for a patrol, security officers heard a crash from within, followed by the sound of heavy boots crushing broken glass. Convinced that an intruder was in the building, the officers drew their weapons, entered the building from the front and rear and began to search.

The guard who came in through the front door saw that the lovely holiday tree was lying on its side, surrounded by glittering shards of broken glass. He stepped carefully around the debris and moved toward the rear of the building, where he met the other officer.

The guard related the details of the overturned tree and smashed ornaments to his partner, which convinced them that an intruder was indeed in the building. Upon their entrance, the intruder must have been driven into the basement or up to the second floor, or was perhaps hiding in some closet or beneath a desk. They began a systematic search of the premises.

After looking through the rest of the house, they found no intruder and no evidence to indicate that anyone could have escaped the building unseen—all the doors and windows were secure and locked from the inside. Reassured that the house was empty but puzzled at the circumstances, the two went out into the foyer to inspect the damage and found the tree upright, every decoration in place and unbroken, lights blinking gently through the branches.

The first guard was stunned. He began to stutter, insisting that he had not been hallucinating or making things up—the tree had been smashed and broken when he'd come in through the door, and he couldn't explain why it was now whole and unscathed. He pointed out that they'd both heard the footsteps and breaking glass from outside the front door.

The other guard didn't need much persuasion because something odd had happened to him in the house the previous summer, an incident he had shared with no one until this evening's events tempted him to confide what happened.

He told his partner that on an August night, with the temperature hanging stubbornly in the red zone and the humidity turning the air to a damp mess, he'd been making his final rounds of the state buildings at 2:00 a.m. when he noticed a light burning in one of the upstairs offices and used his keys to

enter the house. Arriving on the second floor of the building, he discovered that none of the office lights were on and made a quick check to be sure no one was in the building. Once reassured that it was empty, he went back upstairs to see if the light switch in the office was working properly, and to his further confusion, it was.

The air conditioned building felt very good, he confided to his partner, and he couldn't see the harm in taking a break to cool off. He sat down in one of the office chairs, propped his feet on the desk, leaned back and closed his eyes; after a long, hot shift, he couldn't help drowsing.

He awoke a moment or two later, convinced someone was standing over him. Peeking beneath his half-closed eyelids, he saw a figure looming above him, blocking the overhead light, and he became instantly alert. Preparing to apprehend what he thought was an intruder, he was poised to leap to his feet when he felt a sensation of freezing cold hold him immobile in the chair and then saw the crucifix he wore being lifted from his chest as if someone was examining it on its long chain. He leapt to his feet and stared about the room; discovering it empty—the office door open to show an equally deserted hallway—he turned off the light and ran out of the building. His hand shook as he locked the front door behind him. He told the other guard that he did not look over his shoulder to see if the light was back on upstairs because he just didn't want to know.

With a shiver, the two guards locked up the house, glancing back one last time at the twinkling lights of the undamaged Christmas tree before they locked the door on the ghost of a Christmas past.

CHAPTER 13

THE JOHN BRICE II HOUSE

T he gambrel-roofed house at 195 Prince George Street sits back on a lot that rises to the same height as that of the William Paca House across the street. It was built very early in Annapolis history, around 1727, and is said to be haunted by the ghost of the thrice-married and very beautiful Ariana Vanderheyden, who died far away in London but whose angry spirit crossed the Atlantic to chasten her philandering husband.

Many Annapolis families can claim Ariana Vanderheyden (1690–1741) as an ancestress—she had a total of ten children by three husbands. As Bordleys, Frisbys and Jennings, the children were born into the highest ranks of colonial society, and her daughter Sarah Frisby married John Brice II. The young couple lived in the house on Prince George Street (it is commonly referred to as the John Brice II House) with Ariana and her third husband, Edmund Jennings. In the early spring of 1741, Ariana took her younger children on a trip to London to visit the wealthy English branch of the Jennings family.[21]

At the same time on the opposite side of the Atlantic, Edmund Jennings was having an affair with a young woman known to history only as "Miss Turner." Their relationship is said to have been one of the reasons Ariana went to England without her husband. Reportedly furious at his infidelity, she might have given him an ultimatum that Miss Turner better be gone when she returned home.

In April 1741, there was an outbreak of smallpox in London, and after days of suffering, Ariana Vanderheyden Bordley Frisby Jennings drew her

The parlor and hallways of the John Brice II house reportedly are visited by the restless spirit of Ariana Vanderheyden, who died of smallpox in far-away London but returned to chasten her philandering husband and remains within it to this day. *Author photo.*

last breath. On that same day in Annapolis, Miss Turner walked into the parlor of 195 Prince George Street and saw something that led her to leave the house for good. Ariana's great-grandson, the jurist Nicholas Brice, wrote an account of the family story that

> *was communicated to me by my father, John Brice III, her grandson as handed to him by his father: A Miss Turner, who lived in his father's family and [knew] Mrs. Jennings before she went to England, saw a female figure, ill with small pox with her face tied up and sitting under a portrait of Mrs. Jennings. She immediately recognized the likeness of the lady to the figure and believing it to be an apparition, hastily retreated and [told] John Brice II, my grandfather, who was so struck by Miss Turner's narrative that he took down the day, hour, et al. The first letters received from England conveyed intelligence that she had died in April 1741 of the smallpox, corresponding in every respect with Miss Turner's account, even to the hour of her death.*

The portrait of Ariana remained in the house for many years, but even in its absence, the ghostly Mrs. Jennings sits beneath where it once hung—even to the point of bringing her own chair. Residents in the house have observed her on several occasions, and it is said that her appearance signals that someone in the house is breaking their marriage vows or otherwise behaving badly. She is said to walk about the house, crossing from the parlor to go to the stairs to her bedchamber, her footsteps clearly audible on the wooden floors and stair risers. People on the street have looked through the windows to spy a woman's figure, clad in long and sweeping skirts, looking out or climbing the staircase… perhaps heading upstairs to make sure that there are no Miss Turners in the bedroom.

CHAPTER 14

136 DOCK STREET

THE OLD ANNAPOLIS JAIL

If a man was accused of a crime in colonial Annapolis and did not have the money or the reputation to be released pending trial, he would be consigned to the Annapolis jail until his fate was decided. If the crime was a violent one, like rape, murder or assault, death was the usual punishment, but flogging or branding with hot irons were other options. Lesser crimes like burglary or smuggling usually incurred time in the stocks or indentured servitude for a certain number of years or until the fine imposed was repaid. Incarcerating people for lengthy periods was a foreign concept in criminal justice at the time—the only people who spent years behind bars were those who fell into debt. These unfortunates were imprisoned until such a time as they made good on what they owed, which was nearly impossible as they could no longer go out to work. The burden of their incarceration was actually borne by their own families, who not only had to struggle to amass the money to satisfy the debt but also had to buy food for the prisoner.[22] Some debtors were incarcerated for years before they were released, either by the courts or by death.

Murderers and debtors shared the same cells, sleeping on fetid and insect-laden straw and competing for the scant food and water they were given. By all accounts, the jail was a stinking hell in which mosquitoes buzzed, rats abounded and fleas and lice added to the misery. The stronger prisoners preyed upon the weak, and hundreds died of infection or injury within its walls. Violent or particularly despised criminals were chained to the walls,

and some were left hanging in their chains for days after death claimed them, as a lesson for the rest. An official committee report from 1766 describes the conditions as "so filthy and nasty that it is excessively nauseous."

The original building was demolished in the early nineteenth century, but its replacement stands upon the same foundations and is filled with the ghosts of those who died within the walls of the old jail. Employees of the various taverns and restaurants that have occupied 136 Dock Street have reported hearing the sound of clanging metal—one said it sounded like a gate closing—as well as footsteps, racking coughs and hoarse whispers (one recurrent voice in the kitchen area begs for water).

From the street, faces and moving lights have been observed on the ground floor long after the business is closed for the day, and police and others have reported seeing figures entering the building or standing in front of it. Coffles of chained prisoners were sighted at various times in the late nineteenth and early twentieth centuries, moving from the old jail site in the direction of the public stocks and punishment area at the bottom of Main Street but have not been reported in recent decades.

Perhaps these ghosts have grown tired of wandering and have settled into an uneasy tenancy of the building in which they met their ends.

CHAPTER 15

GALWAY BAY

BOOTLEGGERS AND SERVANT GIRLS COME TO A BAD END

The restaurant that occupies this address is actually comprised of two buildings that were connected in the early twentieth century. Both of them were of mid-nineteenth century construction, but each incorporated preexisting walls and foundations that date much farther back in time.

There are two ghosts said to haunt the buildings, one in the basement and the other in the second-floor rooms that have been used for storage space since at least 1923.

The restaurant that preceded Galway Bay in this location was the Little Campus Inn, which was opened in 1919 and closed in 1999. Presidents and politicians of all affiliations sat in the dimly lit bar, eating Solomon's famous "Market Soup" and shooting the breeze with St. John's students, navy midshipmen and locals—and if they stuck around until the game show *Jeopardy* came on, they could bet a dollar on the final question with everybody else.

Ethelda N. Kimbo, the legendary waitress known as "Miss Peggy" to generations of midshipmen and college students, used to warn new employees about the ghost in the basement because she didn't want them to be startled if they saw or heard her. She said that she had seen the misty figure of a young woman walking from the base of the stairs to the corner of the room and related that she'd been told it was the spirit of an orphaned girl who worked as a servant for the family who owned the building in the late nineteenth century. The girl became pregnant, and story says that the

The upper storage rooms of Galway Bay are tenanted by the ghost of a girl who sings and whistles and by the unquiet spirit of a murdered bootlegger. *Author photo.*

man of the house was the father of her baby. She gave birth, and the child died shortly after. Overcome by sorrow, the girl hanged herself in a corner of the basement. Miss Peggy would hear what sounded like someone singing a lullaby or whistling a quiet tune, phenomena that have also been reported in the upstairs storage area.

One of Galway Bay's employees reported that she'd been upstairs by herself and had first heard footsteps in the room next door and then the sound of a girl's voice singing some soothing and indistinct melody; overcome with a sense of cold and covered in goose bumps, the young woman ran downstairs without the items she'd gone to fetch. She returned with another employee, and together they searched the entire floor, but found no one.

Other employees have reported being greeted with a cheerful "Hi!" when they step into the basement and have seen a softly glowing figure in a dress in the small courtyard at the back of the building.

The other haunting in the building is on the second floor, in an area that was used for liquor storage in the old Little Campus. This ghost was

the victim of a homicide that took place during the years of Prohibition, a bootlegger who ran afoul of a gambler who couldn't pay for a delivery.

Prohibition never quite caught on in Maryland, a state that has always liked a good drink, and it was the only state that never passed a state enforcement act to curtail the shipment or creation of liquor. Maryland was a "wet" state that viewed the Eighteenth Amendment and the Volstead Act as an infringement of state's rights, so it didn't enforce the federal law with any enthusiasm. Baltimore was the passionate center of defiance, with several riots and lots of interference with federal law enforcement, like what happened on May 5, 1923:

> *An excited crowd of more than 1,000 people shouted threats of violence to three prohibition enforcement agents who were "engaged in interrupting the transfer of more than 200 cases of real beer from a freight car at a Baltimore & Ohio Railroad warehouse to two trucks," but were forced to permit the escape of one of the trucks. They poured out the bottles that they did confiscate from the other trucks.*
>
> "*BEER RIOT IN BALTIMORE,*" New York Times,
> *May 5, 1923*

In Annapolis, there were regular liquor deliveries to the statehouse and legislative offices, with whiskey and gin hiding in cartons of office supplies or cleaning liquid. And at the Little Campus, there was a regular shipment of booze that showed up on Sunday evenings when the restaurant was closed. The boxes of full bottles would be carried upstairs, payment would be made and then the boxes of empties would be taken down to the truck and the deliveryman would drive away.

The story goes that the employee chosen to meet the bootlegger on the fateful evening was a man with a bit of a gambling problem. Given a hot tip on a horse or a game or some other sure thing, he'd put down the money he'd been given to pay for the liquor, confident he'd make it back and more. Of course, he lost every cent and was faced with a dilemma—how was he going to pay for the alcohol?

Unable to come up with a plan, he kept silent as he helped carry the liquor upstairs; it was not until the man demanded payment that he stuttered out an excuse and tried to negotiate. Evidently, the bootlegger was not interested in negotiation, and at some point in the argument, one of them attacked the other. In their struggle, one of them pulled a knife, which slid neatly between the ribs of the bootlegger and punctured his lung. The man sank

to the floor, gasping for breath, and the employee was so horrified at what had happened that he ran away, leaving the wounded deliveryman to bleed to death on the floor.

Employees have reported hearing the sounds of footsteps in the rooms above the dining room after the restaurant has closed for the evening—sounds that turn to thuds and shuffling feet, as if a fight has broken out. After a moment or two, something large and heavy falls with a thud and there are the sounds of running feet. Then it is mostly quiet, but it is a quiet punctuated by ragged gasping breathing that slowly dwindles away into a silence so cold and sad that there is nothing to do but lock up to go home and leave the building to its tragic memories.

CHAPTER 16

THIRSTY ROLAND, THE UNFORTUNATE MR. HASTINGS AND THE SOLDIERS OF PINKNEY STREET

2 MARKET SPACE: MIDDLETON TAVERN

Middleton Tavern has a long history in Annapolis. In 1750, Elizabeth Bennett sold the property to Horatio Middleton who operated the building as an "Inn for Seafaring Men." Middleton also owned a ferry that linked Annapolis to the Eastern Shore, and after his death, his son Samuel expanded the family's business interests to encompass shipbuilding and overseas trade.

During its heyday from 1750 to 1790, the tavern hosted many famous travelers who were taking the ferry across the Chesapeake. Tench Tilghman stopped there on his way to Philadelphia with news of Cornwallis's surrender at Yorktown, and Thomas Jefferson took passage in 1783 from Annapolis to Rock Hall after dining at the tavern and strolling the extensive gardens that stretched to water's edge.

Several of the guests became so enamored of the hospitality that they never checked out of the building, and one of the cooks liked his job so well that he continues to ply his trade in the kitchen, where employees find cookware moved about and have observed utensils sliding down counters. Footsteps, voices and whistling have all been heard in the building after-hours, and chairs are found pulled out from tables on which the settings are disturbed, as if someone sat down to have a drink.

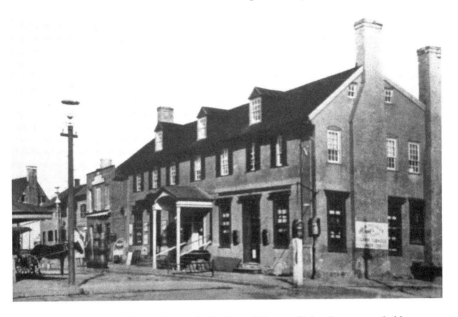

The historic Middleton Tavern site on the harbor of Annapolis has been occupied by a variety of businesses over the years. The original interior gutted by fire, the modern site is once again occupied by a tavern. *Courtesy of the Historic Annapolis Foundation.*

FATAL SHOOTING IN ANNAPOLIS.

BALTIMORE, Nov. 3.—A special dispatch from Annapolis says that during an altercation, originating in a political discussion this afternoon, George Schmidt, proprietor of Marx's Hotel, was shot and killed by William Barber, an employe in Keller's restaurant. It is said Barber was intoxicated at the time. After shooting Schmidt he proceeded to Police Head-quarters and gave himself up.

George Schmidt's murder on November 4, 1875, as it was reported in the *New York Times.*

One of the former owners of the tavern was Charles Schmidt, who was murdered in 1875 in the course of a political argument with an employee, William Barber. Even though his murderer was punished and justice done, Schmidt is said to haunt the area that is now the bar on the

main floor—perhaps keeping an eye on the employees to prevent another political argument from getting out of hand.

The most famous ghost in the building is Roland, who got the name because of his habit of knocking over bottles and rolling them out of sight around a corner where he can consume the contents in peace. Said to have been a regular customer who had an annoying habit of mooching drinks, Roland has been haunting the tavern since the 1770s and has even been known to turn on a beer tap during happy hour when he's feeling thirsty. While he's most active in the main taproom downstairs, there are quite a few stories of people in the upstairs lounge who have observed bottles floating from the back of the bar toward an empty glass on the counter. One of the managers in the 1980s emerged from an upstairs office at the end of the night to find a glass with ice and the remains of a drink sitting on the bar—items that had not been there when he had walked past five minutes before. He confronted the employees left in the building, who indignantly denied making a drink or going upstairs—they'd all been downstairs, closing up. The manager walked back upstairs and picked up the glass, noting that he could smell gin, he looked at the bottles on the back of the bar and noticed that the bottle of Beefeaters was out of place. He locked up for the night, wishing that Roland had decided to drink something less expensive.

HAUNTED ALLEYS AND BYWAYS

The heart of the Historic District is very European in the layout of its streets and blocks. Having a home that faced the street was not a priority in colonial times, and many of the blocks are quite large and had homes and business at their center, with the only access being by alley or private walkway. Many of those historic alleys remain in use downtown, and one of them, with a stair that climbs from Main Street to State Circle, offers a magnificent view of the State House.

One such alley lay behind the Reynolds Tavern, leading from Franklin Street into a cluster of rooming houses and businesses that were crammed in against West Street's buildings on the other side. In this alley, in the late 1770s, Alexander Hastings was brutally beaten to death by men who knew of the gold he was carrying—the profit from a livestock sale. He was making his way down the alley to the rooming house in which he was staying when the attack began, and he managed to break free and run into Franklin Street, where he cried out for help.

Desperate to get their hands on his gold, his assailants dragged him back into the alley and beat him unconscious, where those attracted by his cries for help found him moments later. He never regained consciousness, dying a short time later.

People walking down Franklin Street have reported seeing a man in historical dress staggering out into the street calling for help. They are horrified to watch shadowy figures drag him into the driveway that leads to an interior parking lot, but when they rush to intervene, they find the drive empty. Employees of the Reynolds Tavern have seen him on the street and called police because of the bloody injuries they see on his face; police respond but find no one.

Alexander Hastings is far from the only ghost to haunt one of the alleys in Annapolis; he's just the only one whose name has come down to us. The narrow and dark byways were perfect for robbery or ambush, and areas down by the harbor were particularly dangerous, with murder a common crime in Hell Point. Several ghosts are said to wander near Gate 1 of the modern Naval Academy, and there is at least one in the public alley between Cornhill and Prince George, where residents have seen a man dressed in the style of the mid-nineteenth century leaning against a wall, his face covered in blood.

Alleys in modern Annapolis are safer than their historic forebears, as many of them are lighted and all of them are paved and clean. But beneath the cement, there is blood soaked into the ground, and memories of violence that replay in the current day.

43 Pinkney Street

The Barracks

This small house was like many other middle-class dwellings in Annapolis in the eighteenth century, and land records from 1777 state that the site contained a tenement occupied "by this State for a barracks and by George the Fifer's wife," as well as a house occupied by "Brooks the drummer." A residence in later years, the building was purchased by the Historic Annapolis Foundation and extensively restored, with excavations in the basement revealing a beehive oven and a large kitchen fireplace.

Soldiers were quartered here throughout the Revolutionary War, and while military conflict did not rampage through Annapolis during the war, infection and disease certainly did. Several of the soldiers who died in the

Utilized as a barracks in both the Revolutionary War and the War of 1812, the building is currently owned by the Historic Annapolis Foundation. The figure on the steps is a reenactor, not a ghost. *Author photo.*

barracks are said to haunt the building, but there have only been occasional sightings or observed phenomena.

One story does bear repeating. After a terrific snowstorm in the 1980s, a Historic Annapolis employee went to check on the building, worried that snow on the roof might be putting stress on the structure. She fit her key into the door, and it swung open; to her shock, the building was not empty.

Several men in colonial uniforms were standing next to a fireplace in which logs were blazing. She saw that military gear was strewn about the room and hanging from hooks and noticed that the room was not only warm but was also unpleasantly odorous. Suddenly, the door slammed shut, and the lock was sticky and uncooperative. When she managed to get it open again, the room inside was dark and empty, but she caught the clear fragrance of burning logs and the room was very stuffy. Without stepping inside, she let the door close again, deciding that the roof looked just fine.

EPILOGUE

The streets of modern Annapolis bustle with visitors who know nothing of the ghosts of the past; they come to shop, sail, cheer on a navy football game, lobby the legislature or have a drink at a waterfront bar. They may have no idea of the history they are brushing up against with every step, and they probably have never heard of Mary Reynolds, Joseph Simmons, Thomas Brice or any of the other folk whose ghosts people this book.

But knowing their stories turns a walk down a pretty little historic street to a journey into the past, where the houses become the silent representatives of the personalities who now imbue them. Even those ignorant of its stories find Brice House spooky and oppressive, but in the light of the Crying Girl, the bloodily murdered Thomas and the rest of its ghosts, it takes on whole new levels of creepiness. The breeze along the quiet waterfront near the French Monument now seems to sigh with a Gallic homesickness, the statehouse dome rises with quiet triumph into the sky and the grounds of Government House echo with music and the sounds of a party long over. Going into Reynolds Tavern for lunch, one can sense a woman's comfortable hospitality and, sitting in the basement pub at Ram's Head, feel Amy's lascivious eyes undressing every man in the place. The wind-swept grounds of the Academy are filled with James Sutton's cries for justice, the dimly lit chapel crypt with the advisory murmurs of a naval hero. Pirates dangle in iron cages along the seawall, and convicts shake their chains as the prison doors clang shut.

We are surrounded by the ghosts of the past once we have heard their stories.

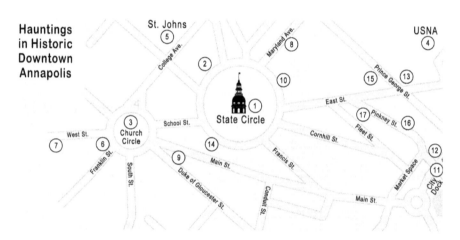

A map for exploring haunted Annapolis. The Historic District is easily walked in under an hour. Keep an eye on your footing and always look both ways before you cross a street (even the one-way streets)—Annapolis has more than enough ghosts already! *Map created by Mike Carter.*

APPENDIX

EXPLORING HAUNTED ANNAPOLIS

The Historic District of Annapolis isn't very large and is easy to explore on foot, and the locations described in this book are fairly close together and can be visited in a single afternoon of walking. In general, most of the buildings are handicapped-accessible, but because of their historic nature, some have areas that are not. Contact the site with any questions (web addresses are given below).

Many of the haunted buildings in Annapolis are open to the public during normal business hours and a few until the late hours of the night, while others are privately owned and may not be visited. Please contact the location for more specific information on access.

1. MARYLAND STATE HOUSE

The building is open to the public every day of the week, although access may be limited during the legislative session (January 15–April 15). There is a mandatory security check at the entrance, and entrance is restricted to the Lawyer's Mall side of the building. Be sure to glance up into the dome gallery, but even if you don't see him, Thomas is listening—be sure to keep any disparaging comments to yourself until you're safely outside!
www.msa.md.gov/msa/mdstatehouse/html/home.html.

2. Government House

Tours of Government House are given on Monday, Wednesday and Friday, from 10:30 a.m. until 12:00 p.m., by appointment only, and open to the public for special events, but the grounds are easily viewed from the street. A historically dressed gentleman who sips a beverage and waves at passersby occasionally occupies the pineapple-topped fountain on the western end of the grounds. It's considered polite to wave back. www.msa.md.gov/msa/homepage/html/govhouse.html.

3. St. Anne's Church

The church building is open most days, but special events and services may limit access; the church grounds, however, are open twenty-four hours a day. The building boasts a beautiful array of stained-glass windows, including one Tiffany window of St. Anne, and the gorgeous woodwork of the interior also deserves a look. Watch out for the scruffy gentleman sitting in a back pew, and if you see him using a shovel in the graveyard, be sure to avert your eyes! www.stannes-annapolis.org.

4. United States Naval Academy

The grounds of the Academy are open to pedestrian traffic but only cars with proper Department of Defense or Academy stickers may enter. Be sure to visit the Academy Chapel, which was renovated in 2009; the restoration uncovered the dome's oculus, a round skylight twenty feet in diameter. The crypt, where the marble sarcophagus containing the body of John Paul Jones lies is state, is below the chapel and is reached by a separate entrance at the side of the building. www.usna.edu.

5. St. John's College

The grounds of the college are open to the public, but access to the buildings is restricted to students, except for public events such as lectures and concerts, which take place frequently in historic McDowell Hall. Visitors are free to stroll down to the French Monument and have a picnic by the waters of College Creek, while keeping a sharp eye out for any of Lafayette's sentries who may still be walking past. There is an annual ceremony (usually in late October) at which representatives of the French and United States governments gather to honor the sacrifice and show appreciation for the support of the French troops who aided the Continental army against the British in the Revolutionary War. www.sjca.edu.

6. Reynolds Tavern

The building has a restaurant and tearoom on the main floor, hotel rooms upstairs and a pub in the basement, and weather permitting, there is a nice outdoor patio for dining. The building has been extensively restored and is a showcase of eighteenth-century construction, with the original beams exposed in the plaster ceiling of the pub (along with a huge fireplace that's lit in the winter months) and beautiful wood floors upstairs. Keep an ear out for the sound of whistling, and be sure to behave yourself in her establishment, as Mary Reynolds is always keeping an eye on the guests. www.reynoldstavern.org.

7. Rams Head Tavern

This establishment is a complex of buildings along West Street that has been extensively renovated and connected. There is a performance venue, brewery, restaurant and upstairs bar, but Amy does most of her flirting in the below-street bar that was the original Ram's Head Tavern. Be sure to have the bartender point out where the bed leg is sticking through the ceiling plaster behind the bar and poke your head into the Tearoom upstairs to see if any thirsty Union soldiers are sitting in the corner. www.ramsheadtavern.com.

8. Galway Bay Restaurant

The bar at Galway, located at 63 Maryland Avenue, is one of the few in town that has no television sets—you'll have to actually talk to somebody instead of spacing out on the football game. Still a local watering hole for legislators, St. John's students and midshipmen, the bar is great for the grown-ups, and the restaurant side perfect for a family meal, with the haunted storage rooms just above your head. www.galwaybayannapolis.com.

9. The Historic Inns: The Maryland Inn

The lobby of the Maryland Inn is open to the public, and the Maryland Inn has both a restaurant and a bar. For a quick nonalcoholic visit, check out the coffee shop that occupies the other half of the inn's basement. An underground tunnel that opened into the wine cellar used to connect it to another building, and thirsty colonial soldiers are still using it to get to the beer. www.historicinnsofannapolis.com.

10. The Historic Inns: The Governor Calvert House

The lobby of the Calvert House is open to the public; check out the second parlor off the entrance hall and look through the glass floor into the historic foundations of the building, and then go down the hall to the display cases that house an array of items recovered during archaeological digs at the site.

11. Dock Street

With family-friendly dining for lunch and an active bar from happy hour until closing, you can catch the sound of clanging irons and whispering voices on the main floor and in the upstairs dining area. www.dockstreetbar.net.

12. Middleton Tavern

Offering family-friendly dining for lunch and dinner, the tavern has live music and a very active bar crowd until closing. Check out the upstairs bar, where leaving a drink unattended may give Roland just what he's looking for!
www.middletontavern.com.

13. Brice House

The building at 42 East Street is currently owned by the International Masonry Institute and is not open to the public, but people still have ghostly encounters with its permanent inhabitants. Watch out for a badly beaten-up man stumbling in the street, and listen for the sound of sobs as you walk past. Photographs taken of the building often have faces looking out of the windows, and other paranormal phenomena have been reported in the vicinity.

14. Brooksby–Shaw House

The building at 21 State Circle now houses Maryland state government offices and is not open to the public.

15. John Brice II House

The building is a private residence; please do not disturb the homeowner.

16. Shiplap House

The building at 18 Pinkney Street currently houses offices for the Historic Annapolis Foundation and is not open to the public.

17. The Barracks

The building is currently owned by the Historic Annapolis Foundation and is occasionally open to the public.
 www.annapolis.org.

NOTES

1. Mary Todd Lincoln, wife of American president Abraham Lincoln, consulted many mediums and spiritualists after the untimely death of her young son. Arthur Conan Doyle, author and creator of Sherlock Holmes, turned to spiritualism and investigation in his later years. Upper-class social events showcased mediums, tarot-card readers and clairvoyants instead of musicians or artists.

2. In a Naval Commission report examining Annapolis as a site for the Naval Academy, an unknown author noted: "A polar expedition is useless to determine the Earth's Axis. Go to Annapolis rather. It should be called the pivot-city. It is the centre of the universe, for while all the world around it revolves it remains stationary. One advantage is that you always know where to find it. To get to Annapolis you have but to cultivate a colossal calmness and the force of gravity will draw you towards the great centre— once there, there is no centrifugal force to displace you, and you stay. By natural evolution your hands disappear in your breeches pockets and you assume the most marked characteristic of the indigenous Annapolitan. No glove merchant ever flourished there. Annapolitans in heaven have heads and wings, their hands disappear. On old tombstones you may see them as Angels, on earth they resemble exclamation points, all heads and tails, like the fish they eat. Natural evolution develops itself in a taste for oysters, as they need no carving, and a phosphorous diet swells the brain ; they talk politics continually. Annapolis keeps the Severn river in its place.

This will be useful when the harbour of Baltimore dries up. Annapolitans are waiting for this. They are in no hurry, they don't mind waiting. Two or three centuries will do it."

3. William D. Morgan of Columbia University, writing for the Historic American Buildings Survey in June of 1967, said: "The Governor's Residence, aside from obvious historical association, is notable in that a Victorian Mansion with mansard roof of 1869 has been remodeled (1936) into a Georgian country house of 5 parts—with hyphens and wings. The Georgian remodeling was good in that there is use of very Maryland Georgian elements…however the scale is entirely too large and the result is a large pile of brick that looks like a Colonial Revival fraternity house of the 1920s…This pile is illustrative of a well meaning attempt on the part of interested persons who understood Annapolis' architectural heritage, but were, in effect, blind."

4. "The original burying ground was located within the oval described by Church Circle; in 1790, however, a prominent parishioner, Elizabeth Bordley, willed the church a tract of land on Northwest Street two blocks away as the site of a new burial ground.

Some remains were removed from the churchyard to the new cemetery and buried indiscriminately in a mass grave, still marked by a small mound; the monuments removed from the churchyard—there were, in fact, probably very few to begin with—disappeared in the course of the removal, probably recycled for use in other building projects.

The tombstones remaining in the churchyard were redeployed for use as 'stepping stones' into the church until the incumbency of the Rev. Edwin M. Van Duesen (1845–47), a New Yorker who, appalled at the neglect of the grounds, installed new granite steps and returned the memorials to 'suitable positions.'

The human remains themselves, which were increasingly stranded outside the limits of the churchyard as the roadbed was widened and the boundaries redrawn, received no special treatment: with the relocation of the cemetery, the site was effectively deconsecrated, and the remains eventually lost their special, protected status." Michael P. Parker, "Mr. Moss's Skull: Changing Responses Toward Accidental Exhumation in Annapolis, Maryland, 1855–2006" (paper presented at the Fifth Global Conference: Making Sense of Death and Dying, Mansfield College, Oxford, United Kingdom, July 9–12, 2007).

5. The common expressions "saved by the bell" and observing that someone is a "dead ringer" for someone else both come from graveyard shift work.

6. Glebe-land: property owned by a parish that is rented to generate income for the church

7. "Elegant brick house adjoining Church Circle, 100 feet front, three-stories high, 22 rooms, 20 fireplaces, 2 kitchens. Rooms mostly large and well finished, and is one of the first houses in the State for a house of entertainment, for which purpose it was originally intended." "To be Rented," *Maryland Gazette*, January 26, 1782 and September 1, 1789.

8. New buildings were traditionally constructed on the foundations of the old throughout Annapolis; many buildings that are of more recent eras have basements with walls that are over three hundred years old. The average street level of Annapolis has been raised by about a foot since colonial times; many older buildings feature basement windows that have been shifted upwards as the streets and sidewalks buried them.

9. "The engrossed copy of the Declaration of Independence was placed on the desk of the secretary of congress, on the second of August, to receive the signatures of the members, and Mr. Hancock, president of congress, during a conversation with Mr. Carroll, asked him if he would sign it. 'Most willingly,' was the reply, and taking a pen, he at once put his name to the instrument. 'There go a few millions,' said one of those who stood by; and all present at the time agreed, that in point of fortune, few risked more than Charles Carroll of Carrollton." John Sanderson, et al., Biography of the Signers to the Declaration of Independence, Volume 7, 256–57.

10. One resident, Mrs. Benjamin Ogle, wrote that Annapolis "would be intolerable were it not for the officers...It's all marquises, counts, etc. I like the French better every hour. The divine Marquis de Lafayette is in town and is quite the thing."

11. Email received July 16, 2011. Name withheld by request.

12. Triangular trade is a term that describes the movement of goods among three ports or regions. Salt cod from Massachusetts was sold to French markets, the wine purchased there was sold in Britain and European luxury items were sold in Boston. The most famous example of this is the molasses-rum-slaves route that saw ships selling rum in Europe to purchase manufactured goods that were exchanged for slaves in the African ports that were shipped to the Caribbean islands to grow sugar cane to make molasses that was distilled into rum.

13. The "Jolly Roger" is not one flag, but many—a term used to describe any pirate ensign. They were usually plain black squares, but some pirates embellished their flags with personal emblems or common symbols of

death, such as a skull or hourglass. The style most often associated with pirates (thanks largely to Walt Disney) is the crossed bones topped by a skull, which was flown by several famous pirates in the early eighteenth century.

14. Fort Severn was located at the tip of Hell Point and Fort Horn on the Eastport peninsula; both had artillery that could fire upon ships attempting to enter or leave the harbor.

15. Jones's body was in a remarkable state of preservation, and identification could be made by comparing the face with that of the death mask that Jones had commissioned prior to his death. French doctors were able to conduct a meticulous examination of the body, confirming the cause of death (interstitial nephritis).

16. "Sutton Letters Evidence in Court," *New York Times*, August 9, 1909.

17. At this writing, no episodes have been televised but at least one is scheduled to air in 2012 and purportedly has video of Lieutenant Suttons's ghost. The compelling story of the falsely accused marine who was able to reach from beyond the grave to testify against his own murderers was the subject of the 2007 book *A Soul on Trial: A Marine Corps Mystery at the Turn of the Twentieth Century* by Ella Sutton's great-granddaughter, Robin R. Cutler.

18. Maryland Historic Trust, James Brice House: Historic Sites Survey, National Park Service, 7/30/1974.

19. Researchers Unearth Signs of a Lasting Black Tradition: Ritual Hoodoo Materials Found in Annapolis House," *Baltimore Sun*, February 20, 2000.

20. Source: Archaeology in Annapolis, The James Brice House, www.bsos. umd.edu/anth/aia/brice.html

21. The Maryland Jennings family (also spelled Jenings, Jenyngs) was related to Sarah Jennings Churchill (1660–1744), the wealthy and powerful Duchess of Marlborough, whose English descendents include Winston Churchill and Lady Diana Spencer, later Princess of Wales.

22. Meals served at the jail were usually cooked grains like porridge or gruel, served in small portions and offering little nutrition. Without fresh meat or vegetables, prisoners lost their teeth to scurvy or suffered other diseases of malnutrition.

SOURCES

INTERVIEWS

The employees at these locations were generous with their time and their experiences but wished to have their individual names withheld:

Galway Bay Restaurant
The Historic Annapolis Foundation
The Maryland Inn
Maryland State House
Middleton Tavern
Rams Head Tavern
Reynolds Tavern
St. Anne's Church
St. John's College
The Sly Fox Pub
The United States Naval Academy

PRINT RESOURCES

Baltimore Sun Archive
Maryland Capital-Gazette Archive
Maryland State Archives
New York Times Archive

BOOKS

Anderson, Elizabeth B. *Annapolis: A Walk through History*. Centerville, MD: Tidewater Publishers, 1984.

Freehling, William W. *The Road to Disunion: Secessionists at Bay 1776–1854*. New York: Oxford University Press, 1990.

Papenfuse, Edward C. *In Pursuit of Profit: The Annapolis Merchants in the Era of American Revolution, 1763–1805*. Baltimore, MD: The Johns Hopkins University Press, 1975.

Potter, Parker B. *Public Archaeology in Annapolis: A Critical Approach to History in Maryland's Ancient City*. Washington, D.C.: Smithsonian Institute Press, 1994.

Matthews, Christopher N. *An Archaeology of History and Tradition: Moments of Danger in the Annapolis Landscape*. New York: Kluwer Academic/Plenum Publishers, 2002.

McWilliams, Jane Wilson. *Annapolis, City on the Severn: A History*. Baltimore, MD: The Johns Hopkins University Press, 2011.

Riley, Elihu S. *The Ancient City: The History of Annapolis, in Maryland, 1649–1887*. Annapolis: Annapolis Record Printing Office, 1887.

Sanderson, John, Robert Waln and Henry Dilworth Gilpin. *Biography of the Signers to the Declaration of Independence*, Volume 7. Philadelphia, PA: R.W. Pomeroy, 1827.

ABOUT THE AUTHORS

Mike Carter began his ghost tour in 2002 after six months of extensive research into the history and haunting of Annapolis. He is a successful entrepreneur and marketing consultant who has been part of numerous technology start-ups and has consulted with the city of Annapolis on various projects pertaining to tourism in the historic city. Mike attended the University of Maryland at College Park where he earned a bachelor's degree in English while also working out of the Dingman Center for Entrepreneurship, which incubated his love for business. When weekends came around, he could often be found in historic Annapolis, walking the street and visiting the city's many haunted pubs. His very popular and highly regarded Annapolis Ghost Tours is consistently rated in the top five paranormal tours in the country and can be found at

www.annapolisghosts.com. Mike lives in Annapolis with his wife and young son, and when he isn't out stalking ghosts or interesting historical tidbits, he can be found out on the Chesapeake Bay sailing competitively.

Julia Dray is a professional musician, writer and performer who has lived in Annapolis since 1983. After attending St. John's College, she worked as a restaurant manager, technical writer, magazine editor and pianist before joining Annapolis Ghost Tours in 2007; locals and visitors alike know her as "the ghost tour lady." After eighteen years in the suburbs raising two children, she once again resides in the Historic District, sharing an apartment with her daughter and their three cats: Bob, Alexander the Great and Bastet. She is currently working on a novel set in the Historic District.

Visit us at
www.historypress.net

Printed in the USA
CPSIA information can be obtained
at www.ICGtesting.com
LVHW010834021023
759853LV00002B/9